IMAGES
of America

LAKE FOREST DAY
100 YEARS OF CELEBRATION

D0891014

IMAGES
of America

LAKE FOREST DAY
100 YEARS OF CELEBRATION

Lake Forest-Lake Bluff Historical Society

ARCADIA
PUBLISHING

Published by Arcadia Publishing
Charleston SC, Chicago IL, Portsmouth NH, San Francisco CA

Printed in the United States of America

Library of Congress Catalog Card Number: 2008922823

For all general information contact Arcadia Publishing at:
Telephone 843-853-2070
Fax 843-853-0044
E-mail sales@arcadiapublishing.com
For customer service and orders:
Toll-Free 1-888-313-2665

Visit us on the Internet at www.arcadiapublishing.com

*This book is dedicated to the memory of George Alexander McKinlock
for his bravery and exemplary patriotism.*

CONTENTS

ACKNOWLEDGMENTS

I would first and foremost like to thank Janice Hack, executive director, and Sara Gonzales, curator, of the Lake Forest-Lake Bluff Historical Society for their input and guidance. I am proud to volunteer at such a professional institution. A book such as this does not happen without the help of many. I would also like to thank Shirley Paddock, Kay Weston, Jan Kerrigan, and Audrey Semmelman for the research and fact checking that they provided. I was indeed lucky that Carrol Herber, Sharon Nudel, Ellie Borders, Basil Borders, Byron Karzas and Kay Wawrzyn shared their expertise in proofreading. Many community members graciously shared their photographs and histories for inclusion in the book.

I must acknowledge that Lake Forest Day 2008 would not be possible without a dedicated group of volunteers from the American Legion McKinlock Post 264 and the Auxiliary. The committee is composed of David Lee, Bud Turner, Bill Malich, Jim Gannon, David Burgess, Ed Smith, Mike Welsh, Lloyd Yakes, Bill Gretz, Dan Delozier, George Kouba, Vinnie Dolan, Tom Marks, Al Champ, and Tom Glover.

Many local citizens are working on the Lake Forest Day Centennial Celebration, chaired by Jack Preschlack. Others, including Howard Adams, Art Wood, Willard Bunn, Dave Nash and Bud Turner, are working to endow the future of Lake Forest Day by establishing the Lake Forest Day Foundation. May the tradition continue for another fruitful and successful century.

—Laurietta Parsh, May 2008

INTRODUCTION

In 2008, our community celebrates the 100th anniversary of Lake Forest Day. Three main organizations have been instrumental in the development of this celebration. The Lake Forest Woman's Club initiated the day at the suggestion of the Young Men's Club. The Young Men's Club sponsored the day until 1921, when the American Legion took over and continued the tradition. Lake Forest Day continues to be a success because of the many community volunteers who plan, organize, and turn out for the celebration.

Lake Forest, 30 miles north of Chicago, is one of the oldest planned communities in the United States. In 1856, a group of men wanted to find a location for a Presbyterian university. They rode the train north until they found an area that was perfect for their purposes.

When they wanted to name the community, they looked around—to the east was Lake Michigan and to the west was a large forest—hence the name "Lake Forest." The men organized the Lake Forest Association to purchase land in preparation for three institutions of learning: a university (Lake Forest College), a preparatory academy for young men (Lake Forest Academy), and a female seminary (Ferry Hall). Although there were clusters of farms and homes in the area as early as 1835, the founding of Lake Forest College and Lake Forest Academy changed the landscape dramatically. The original plat of the city of Lake Forest was completed in 1857, in direct response to plans for the Presbyterian schools near the lake. The Lake Forest plan, platted in 1857 by Almerin Hotchkiss, reflected the idea of a city in a park. The streets were laid out in a curvilinear manner that took into account such natural features as ravines and bluffs instead of forcing the street plan into a formal grid pattern.

By the beginning of the 20th century, large meat packers and other prominent businessmen from Chicago built their summer homes in Lake Forest. Large mansions were built and estates were formed. Many of these homes still exist, while others have been razed and houses in the character of Lake Forest built in their place.

Lake Forest is a beautiful city that lives up to its name. It is beautifully green in the summer, puts on a show in the fall with its reds, yellows, and golds, and is abundant with ravines that feature trillium and bluebells in the spring.

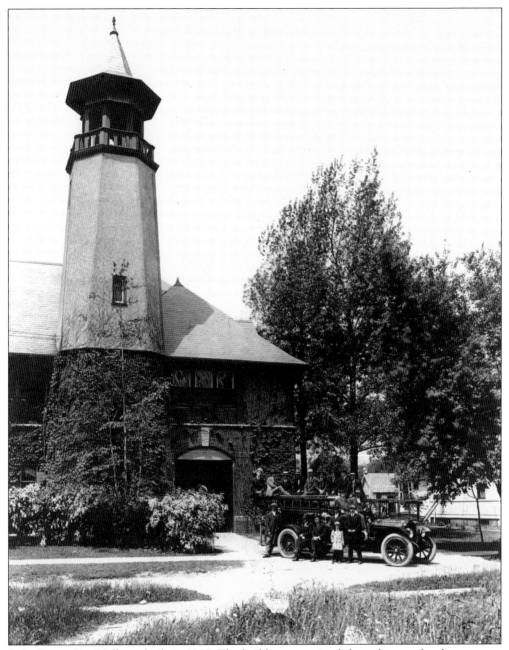

Lake Forest City Hall was built in 1898. The building contained the volunteer fire department, police department, public library, as well as all the city offices. The tall tower contained a bell that was used to call firemen. On Armistice Day, at the end of World War I, an enthusiastic bell ringer pulled so long and hard on the bell that it cracked and was never used again. (Courtesy of Lake Forest-Lake Bluff Historical Society.)

One

LAKE FOREST, 1908

Lake Forest in 1908 had a population of about 2,000. Most citizens lived reasonably close to the business district. There were many fine houses along Lake Road, Sheridan Road, Green Bay Road, and Deerpath. Few streets were paved, and sidewalks were made of wood. Lake Forest boasted two livery stables. There were a few early-model automobiles. One of the problems was to regulate their speed to a maximum of 15 miles per hour.

Business consisted entirely of small retail establishments. Among these were the Anderson Grocery and Dry Goods Store, Krafft's Drug Store, Wenban's Livery and Funeral Parlor, O'Neill Hardware Store, Fitzgerald's Plumbing, and the Murrie Blacksmith Shop. The old Deer Path Inn, a wooden building on Deerpath just east of McKinley Road, offered hotel accommodations and food.

Lake Forest was an educational center. There were two public schools, Gorton and Halsey. Private schools were Alcott School (which later became Bell School, then Lake Forest Country Day School), Ferry Hall, Lake Forest Academy, Lake Forest College, and a girls' school run by the Sisters of the Sacred Heart. High school–age students not attending the private schools went to Deerfield-Shields Township High School in Highland Park. The two townships combined in 1907 to establish the school in the belief there would be no need for a separate one in Lake Forest. The Lake Forest students took the electric interurban train to school every day.

Alice Home Hospital was on the Lake Forest College campus. This small hospital could not handle contagious patients and the need for a contagious hospital was being discussed among local residents.

The fire department had a very efficient volunteer force, and a three-man police force was sufficient to cope with the city's law enforcement. Onwentsia Club was the gathering place for the leading residents and their families for golf, tennis, polo, riding and social events. Life was pleasant, without too much rush or pressure.

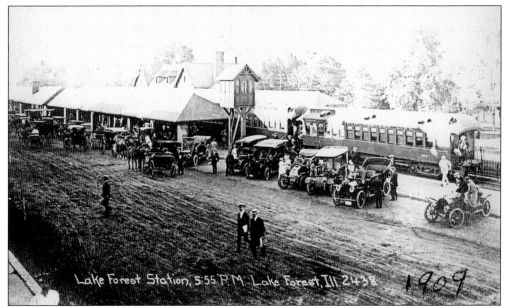

This photograph shows the Chicago and North Western Railroad station, as it looked when the first Lake Forest Day was taking place. The 1900 station was designed by architects and local residents Alfred Frost and Charles Granger. Their father-in-law, Marvin Hughitt, was the legendary chairman of the Chicago and North Western Railroad and expanded it greatly over the 50 years he was associated with the company. (Courtesy of Lake Forest-Lake Bluff Historical Society.)

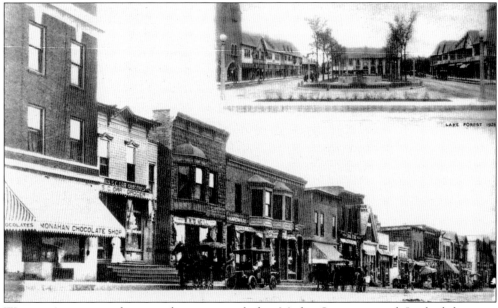

Western Avenue was the main shopping area before Market Square opened. In the left corner is Monahan's Chocolate Shop. Edward J. Monahan worked with the Lake Forest Woman's Club to plan the celebration. Some of their meetings were held at Monahan's Chocolate Shop. Monahan also allowed the Young Men's Club to use his meeting rooms until the club outgrew them. (Courtesy of Lake Forest-Lake Bluff Historical Society.)

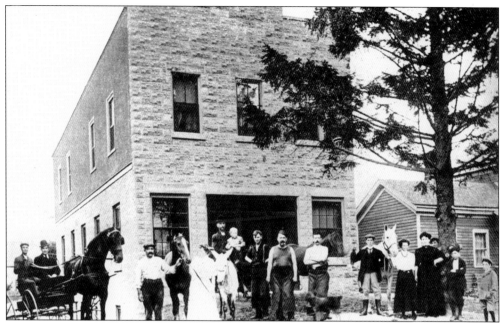

The Murrie Blacksmith Shop was one of the important businesses in town when Lake Forest Day started, in an era when the automobile was still a new invention. Alan Murrie was one of the businessmen who helped plan and organize the first Lake Forest Day. (Courtesy of Lake Forest-Lake Bluff Historical Society.)

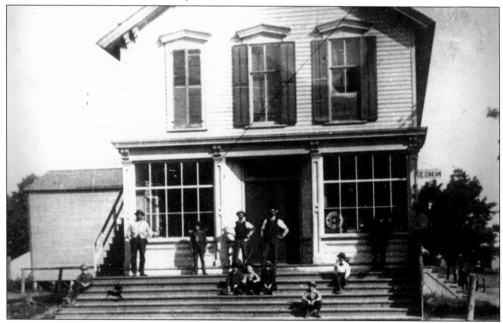

James Anderson, one of the men standing in front of Anderson Grocery and Dry Goods Store, was chairman of the finance committee for the first Lake Forest Day. Just before the festivities began, he reported that there was $250 of available funds. Merchants donated most of the items needed for the food stalls such as bananas, musk melons, lemons, milk, and cream. (Courtesy of Lake Forest-Lake Bluff Historical Society.)

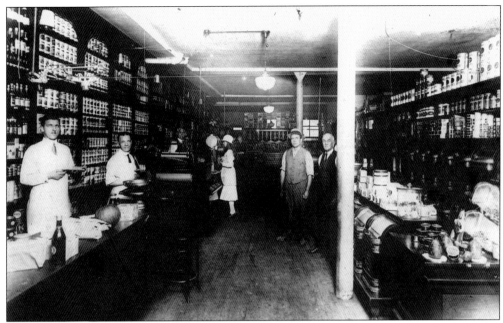

James Anderson's Anderson Grocery and Dry Goods Store was one of the early businesses in Lake Forest, beginning in 1862. One of the largest businesses in town, this interior of the store shows the clerks, owners, and customers. The store supported the year-round residents associated with Lake Forest College, the area farms, and the burgeoning summer estate community. (Lake Forest-Lake Bluff Historical Society.)

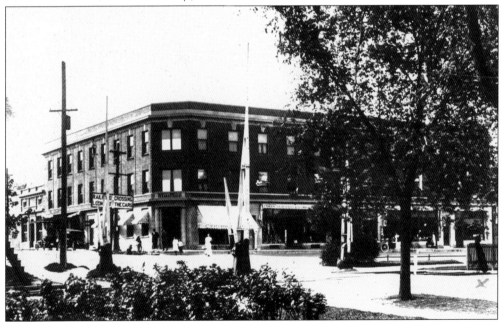

Anderson was a prominent local merchant who helped with the first Lake Forest Day in 1908. He built this building, the Anderson Building, which housed his store and other businesses. The building stands on the northwest corner of Deerpath and Western Avenues. (Courtesy of Lake Forest-Lake Bluff Historical Society.)

John E. Fitzgerald owned and operated a plumbing and heating business in Lake Forest in the early 20th century. He was one of the prominent businessmen who helped the Lake Forest Woman's Club with the first Lake Forest Day. Fitzgerald's Plumbing stood at the southwest corner of Bank Lane and Deerpath. (Courtesy of Lake Forest-Lake Bluff Historical Society.)

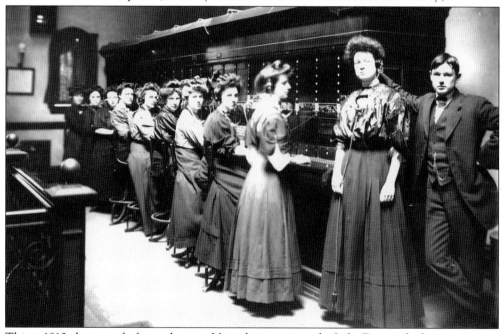

This c. 1910 photograph shows the switchboard operators at the Lake Forest telephone company. Lake Forest's first switchboard brought Chicago, San Francisco, and New York directly to local homes. Amenities such as the telephone encouraged the development of Lake Forest as a residential suburb for Chicago businessmen to summer in and eventually as a place to live. (Courtesy of Lake Forest-Lake Bluff Historical Society.)

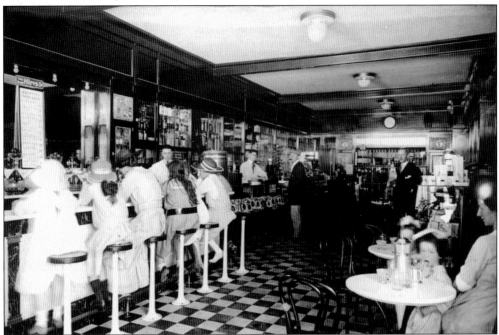

Krafft's Drugstore was a gathering place for the young people in Lake Forest starting in 1902 until the fountain was finally closed in 1972. The Krafft family helped the Lake Forest Woman's Club start the first Lake Forest Day. (Courtesy of Lake Forest-Lake Bluff Historical Society.)

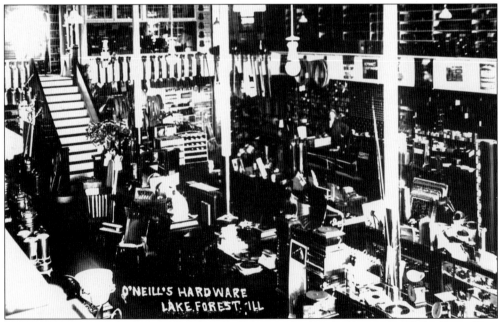

The O'Neill family, who ran this hardware store, was instrumental in starting Lake Forest Day. Mrs. Charles O'Neill organized the booths, while Walter O'Neill chaired the parade committee and organized the baseball game and the races. The O'Neill Hardware Store began in Lake Forest in 1868 and continued in business until 1997. It operated as O'Neill's True Value from 1976 through 1997. (Courtesy of Lake Forest-Lake Bluff Historical Society.)

Alice Home Hospital was built on the Lake Forest College campus in 1898. It was common at the end of the 19th century for patients with contagious diseases, such as tuberculosis, to be quarantined, and Alice Home Hospital did not have this type of accommodation. The profits from the first Lake Forest Day were used to address this need for a separate facility, commonly called contagious hospitals. (Courtesy of Lake Forest-Lake Bluff Historical Society.)

The Lake Forest Woman's Club voted to use two-thirds of the profits from Lake Forest Day for a new contagious hospital. The estate of Charles Farwell donated land, and Mrs. Cyrus McCormick made a generous gift to ensure the success of the project. C. D. Frost designed the hospital, built on the grounds of South Park. The contagious hospital was affectionately nicknamed the "Pest House." (Courtesy of Shirley Paddock.)

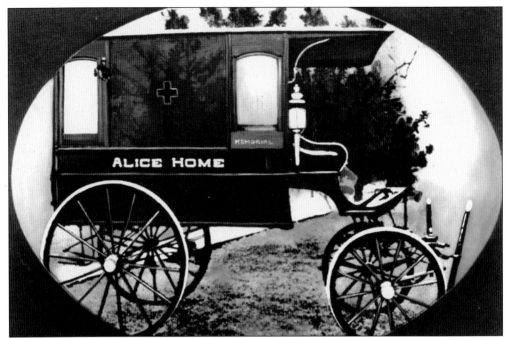

This horse-drawn wagon served as an ambulance. Alice Home Hospital and the contagious hospital served the city of Lake Forest for many years, until they were replaced in the 1940s with the modern Lake Forest Hospital. The new hospital was designed by Stanley Anderson and built on land donated by Mary Dick, widow of the mimeograph inventor, Albert Blake Dick. (Courtesy of Lake Forest-Lake Bluff Historical Society.)

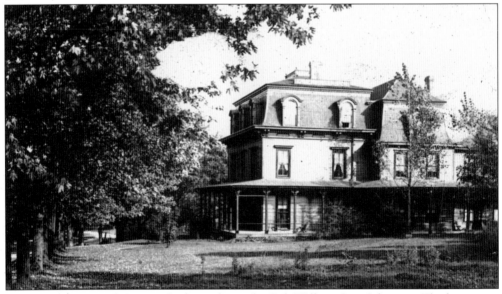

The original Deerpath Inn was built as a home for Col. William Sage Johnston. The house was moved one block north in 1894 to make room for Gorton School and converted into a hotel by Kate Lancaster Brewster. Around 1906, the Patterson family operated the hotel and gave the inn its renowned name, the Deerpath Inn. The new Deer Path Inn, on Illinois Avenue, opened in 1929. (Courtesy of Lake Forest-Lake Bluff Historical Society.)

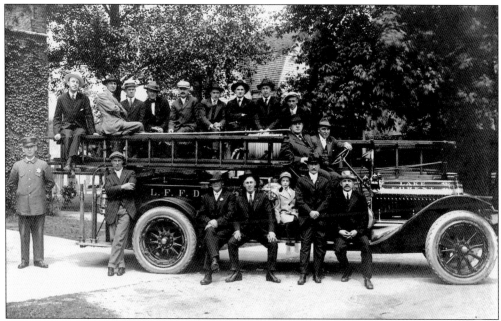

In 1915, the volunteer fire department of Lake Forest proudly posed with their first motorized fire engine which had been purchased two years earlier. This truck was kept at Lake Forest City Hall. In the event of a fire, the bell in the tower was rung to summon firefighters. When the news that World War I had ended reached Lake Forest, the bell ringer was so enthusiastic in ringing the bell that it cracked and was never used again. (Courtesy of Lake Forest-Lake Bluff Historical Society.)

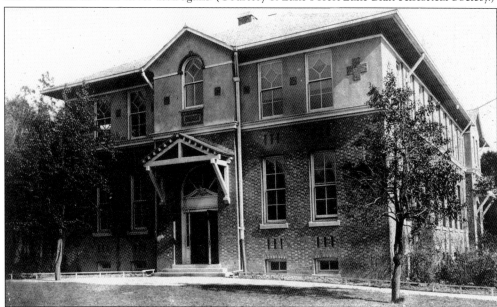

Gorton School was built in 1894 as Central School. The name was changed in 1905 in honor of the former mayor Edward F. Gorton. Gorton School served various grades until 1972. After plans were announced to tear the building down, community leaders, led by Brooks and Jackie Smith, campaigned to keep the historic building for the much-needed Gorton Community Center. (Courtesy of Lake Forest-Lake Bluff Historical Society.)

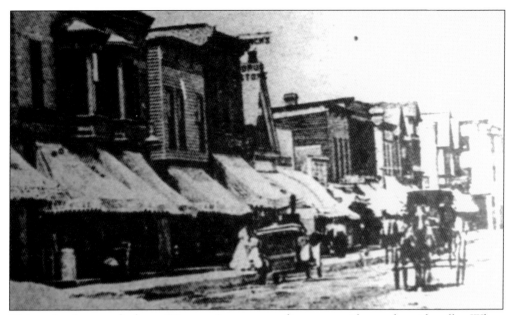

This early photograph shows Western Avenue as a dirt street with wooden sidewalks. When the Lake Forest Association planned the area around Lake Forest College in 1857, businesses were restricted to the area west of the railroad station along Western Avenue. Roads from the college and residential areas surrounding it generally led to the railroad station across from these stores. This block was replaced by Market Square in 1916. (Courtesy of Lake Forest-Lake Bluff Historical Society.)

The Lilacs was built in 1872 and located at 645 East College Road, near the Lake Forest College campus. The original owner was grocer Simon S. Reid, who moved to Lake Forest in the wake of the Chicago fire to join in the development of both the Presbyterian university and the community. Many of the buildings on the college campus are named for him and his family. (Courtesy of Lake Forest College.)

Two

LAKE FOREST DAY, THE BEGINNING

The Lake Forest Woman's Club met with Dr. Theodore S. Proxmire of the Young Men's Club in 1907. They discussed the possibility of holding a community fair to earn money for the development of a contagious hospital. After a long discussion, the group decided to take on the task, and planning for Lake Forest Day began. Dr. Elva A. Wright, president of the Lake Forest Woman's Club, consulted with the city council and, with the help of local businessmen, came up with an exciting and innovative idea for the community day.

The first Lake Forest Day was held on Farwell Field at Lake Forest College in 1908. For the sum of 25¢ (for everyone over age 17) and free admission for children, a day of fun and excitement could be found. A food tent had everything from complete meals to sandwiches, which made it easy for people to stay the full day and evening.

Many types of races were run including foot races, a potato race, egg and spoon races, and a greased pig chase. The married men played a baseball game against the single men. Throughout the day there were performances of a mind-reading dog, palmistry, and fortune telling. Booths were located around the grounds selling hats, fans, umbrellas, homemade candy, and baked goods. There was a voting booth, where for 5¢, visitors could cast a vote for the prettiest girl or the handsomest man.

The highlight of the day was a hot air balloon ascension with a young black man swinging from a trapeze. He then made a parachute jump and landed safely on the grounds of the South School. In the evening, a traveling vaudeville show performed. A dance was held with the music of the Young Men's Club Band and the Lake Forest Orchestra.

The Woman's Club donated two-thirds of the proceeds, $857.40, towards the building of the new contagious hospital. A few days earlier, the Charles Farwell estate had donated land for the hospital.

An intelligent and open-minded woman, Grace Durand was both a socialite and a farmer. She owned and operated Crab Tree Farm in Lake Bluff, a model dairy farm. She lectured across the United States on the subject of dairy farming and was respected as a successful businesswoman. Her contribution to the first Lake Forest Day in 1908 was the donation of a pig for the greased pig chase. (Courtesy of the Vliet Museum of Lake Bluff Area History.)

Farwell Field, on the campus of Lake Forest College, held the Lake Forest Day festivities from 1908 to 1916. There were booths that had ladies' fans, stylish hats, thin lacy scarves, and parasols for sale to the young ladies. Some of the booths contained games of chance and other entertainments. Now a football field, Farwell Field was used by the Chicago Bears for training from 1979 to 1997. (Courtesy of Lake Forest College.)

John Spellman and his twins, Bob and Ray, won a prize in the first Lake Forest Day in 1908. There were multiple baby-related contests, including who could carry their baby the best. According to the *Lake Forester*, "The prize to the father carrying his baby the best was awarded to Alderman J.H. Spellman for carrying the twins, one on each arm." (Courtesy of Chris Johnson/Spellman family.)

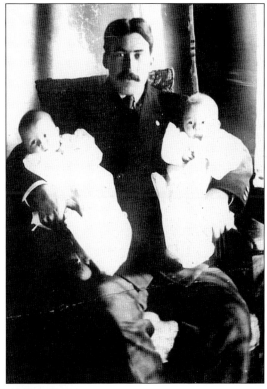

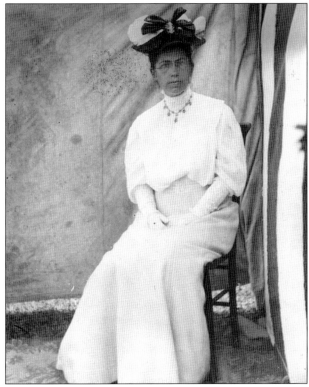

Josephine Laflin sat and posed for the fair photographer at the first Lake Forest Day in 1908. A tent was set up for the fairgoers to memorialize the day with a formal photograph. (Courtesy of Lake Forest College.)

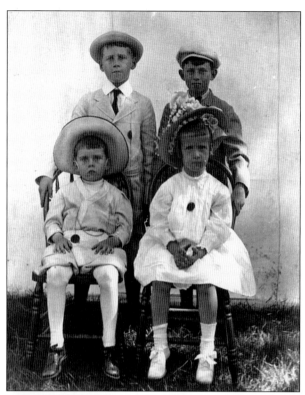

Many families took advantage of the presence of a professional photographer at the first Lake Forest Day celebration. From left to right, (first row) Lloyd Laflin and Alice Carpenter; (second row) Keith Carpenter and Ellsworth Laflin stay very still for their portrait at the first Lake Forest Day in 1908. (Courtesy of Lake Forest College.)

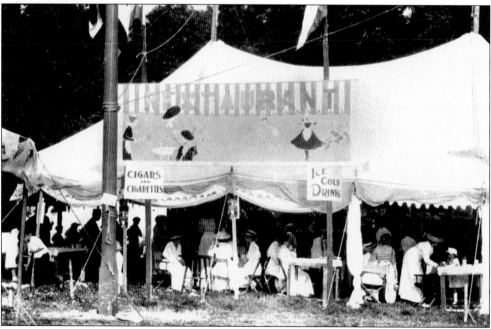

The refreshment tent of the 1915 Lake Forest Day celebration was a very popular place to visit. The local men and women brought homemade meals to sell. Lemonade, ice cream, sandwiches, and other delicious items were sold in the huge tent. It was also a good place to sit and rest weary feet. (Courtesy of Lake Forest College.)

In 1915, William C. Gamble traveled from Chicago to walk around the grounds of the fair portraying Aunt Jemima. Mrs. Louis E. Laflin stops to chat with Aunt Jemima and see what is being offered for sale. Aunt Jemima was a famous commercial character who advertised pancake syrup and pancake mixes. Aunt Jemima traveled around the country visiting fairs and other celebrations. (Courtesy of Lake Forest College.)

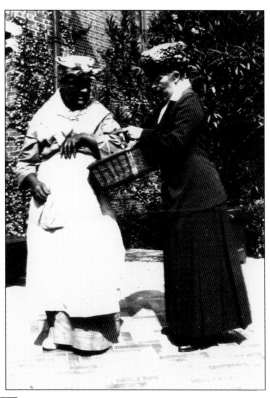

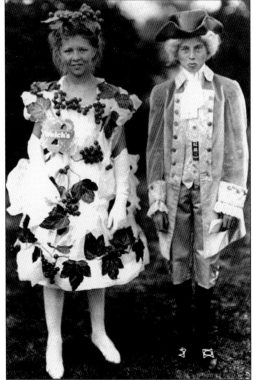

Edith Cummings and Ellsworth Laflin are shown ready for the parade in 1911. A photographer was set up at the carnival to take pictures of the Lake Forest Day revelers. Laflin later became a member of the American Legion Post 264. As an adult, he became an announcer at the Lake Forest Day parade ceremonies. (Courtesy of Lake Forest College.)

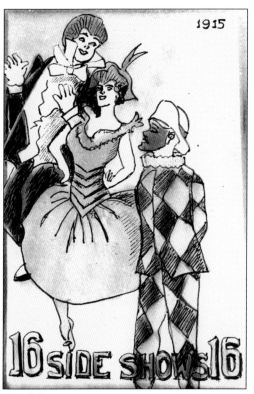

This 1915 poster was used to advertise the carnival at Lake Forest Day. Along with the booths of items to sell and games, there was a tent featuring sideshows to amaze young and old alike. (Courtesy of Lake Forest College.)

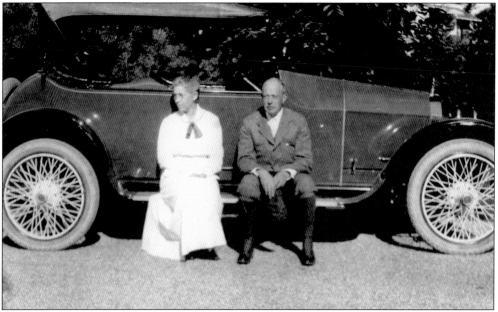

Josephine and Louis E. Laflin show off their 1916 Scripps Booth V8 which was used in the 1917 Lake Forest Day parade. Louis was trained as an architect at the École des Beaux Arts in Paris and participated in the design of his 1907 estate, Ellslloyd. He was a descendant of Col. Elmer Ellsworth, a respected Civil War soldier who drilled troops at Lake Forest College in 1859. (Courtesy of Lake Forest College.)

Three

LAKE FOREST
WOMAN'S CLUB

The first Lake Forest Day was organized in 1908 by the Lake Forest Woman's Club. Several women met in November 1902 to formalize a club. The club was formed to "Bring together those interested in the intellectual culture and improvement of women along practical lines; to promote agreeable and useful relations among its members; to improve the moral and social conditions of the community; and to advance the general welfare of humanity."

The first president was Dr. Elva A. Wright who had a medical practice on Western Avenue. Many of the early members included wives of business leaders in the community. The membership fee was $1 per year.

Women's clubs were originally organized in the late 1860s as vehicles for middle-class women to pursue social and literary interests in the company of other women. Small groups met in each other's homes to study art, music, history, geography, and literature. By the beginning of the 20th century, most clubs had changed their focus to include philanthropy and civic concerns. Club women across the country set up libraries, trade schools, and raised money to fund city parks. These women also lobbied local governments for clean water, better disposal of refuse, and public health legislation. The Lake Forest Woman's Club actively participated in these types of civic duties.

The organization's slogan of "Unity, Helpfulness and Advancement" was carried out by broad and varied philanthropic activities over the years. Among their achievements were introducing a visiting nurse to the public schools (1912), arranging for hot lunches at the schools (1914), organizing the first PTA (1926), sponsoring demonstrations of voting machines (1936), and establishing a mobile chest x-ray unit to screen for tuberculosis (1949). Since 1929, the club has given scholarship awards totaling over $200,000.

In 2002, the Lake Forest Woman's Club celebrated its centennial of community service with an exhibit and program at the Lake Forest-Lake Bluff Historical Society.

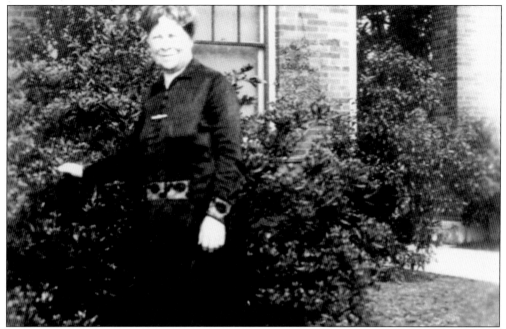

Dr. Elva A. Wright, a physician who moved from Texas, was president of the Lake Forest Woman's Club from 1902 through 1909. During her reign as president, planning started on October 16, 1907, for a community day to be held in August 1908. Dr. Wright's office was on Western Avenue. (Courtesy of the Lake Forest Woman's Club.)

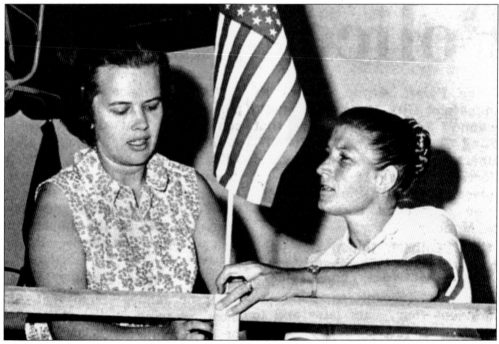

The Lake Forest Woman's Club organized the first Lake Forest Day in 1908. The club members participated in many parades throughout the 100 years. Phyllis Freed (left), float chairman, and Carol Baldwin, club treasurer, work on the 1966 entry. (Courtesy of Pioneer Press © 2008.)

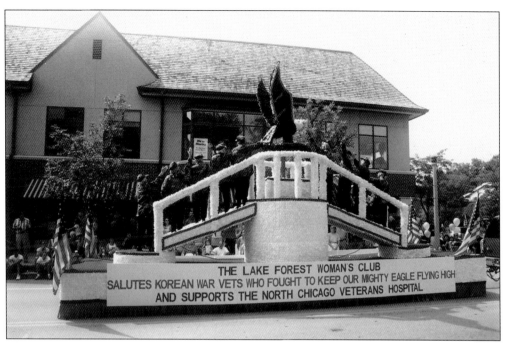

The Lake Forest Woman's Club floats have frequently been intricate and ornate. They have often been a winner in their division. This entry salutes veterans of the Korean War and the North Chicago Veteran's Hospital. (Courtesy of Roger and Pauline Mohr.)

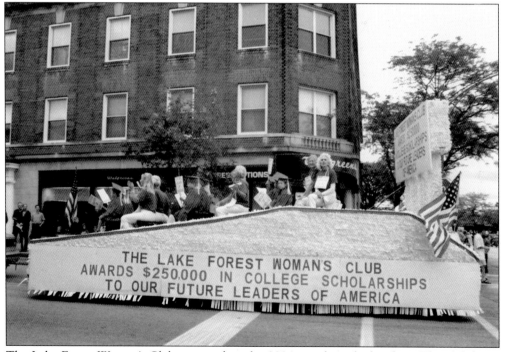

The Lake Forest Woman's Club appeared in the 2004 parade with this float. The club has a strong philosophy of philanthropy and has an ongoing program to award nursing scholarships to deserving women. (Courtesy of Jean Grost.)

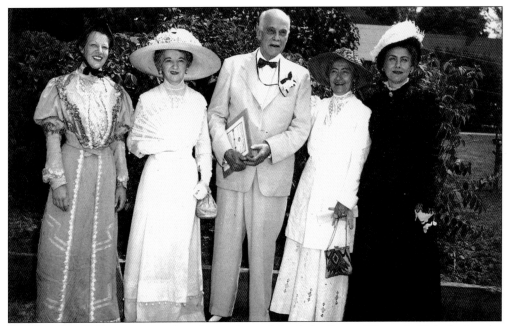

Dr. Theodore S. Proxmire posed with members of the Lake Forest Woman's Club during the 1955 Lake Forest Day. The ladies dressed in costumes reminiscent of 1908, the year in which the club planned the first Lake Forest Day at Dr. Proximire's suggestion. (Courtesy of Lake Forest-Lake Bluff Historical Society.)

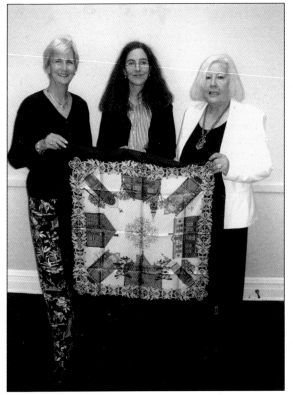

The Lake Forest Woman's Club celebrated their 100th anniversary in 2002 with an exhibit at the Lake Forest-Lake Bluff Historical Society. As part of the anniversary, the club commissioned a scarf with historical scenes of Lake Forest. Janice Hack (center), executive director of the Lake Forest-Lake Bluff Historical Society, is shown here accepting a scarf for the museum collection from Romayne Kazmer (left), president, and Suzanne Laundry (right), historian, of the Woman's Club. (Courtesy of the Lake Forest Woman's Club.)

Four

YOUNG MEN'S CLUB

The Young Men's Club started in the fall of 1906. Boys and young men in town needed a place where they could meet and enjoy sports. The pastor of the Presbyterian church, Dr. W. H. W. Boyle, assisted in starting the club. As membership increased they rented quarters in the O'Neill Building, creating an area as a gymnasium. The basement of the building contained lockers and shower baths. Rooms on the second floor provided space for reading, lounging, and assembly purposes.

The original purpose of the club was to "furnish healthy social intercourse among its members; to promote good fellowship between them and furnish them entertainments; to develop athletics; to further and support all movements and enterprises calculated to benefit Lake Forest; and to own and manage a club house for the forgoing purposes." The first slogan of the club was "No class, no creed."

In 1907, the club acquired title to the entire district known as the Young Men's Club Subdivision, previously part of the William Atteridge Farm. Land was set aside for a park. The remainder was divided into building lots with the exception of one large triangular lot that was set aside for the building of a clubhouse. The sale of the lots netted $12,000 for the club's building fund. The park, later known as West Park, was sold to the city for $4,000.

The idea for a clubhouse in West Park was abandoned, and about 1910 plans were developed for a clubhouse near Market Square. The new building on Forest Avenue included a gymnasium, lockers, shower rooms, reading rooms, auditorium, bachelor quarters, kitchen, and a caretaker's apartment. A bridge was built to connect the clubhouse with the second floor of the bank building, later Marshall Field's, where the YWCA held meetings. This bridge enabled the women to use the Young Men's Club gymnasium.

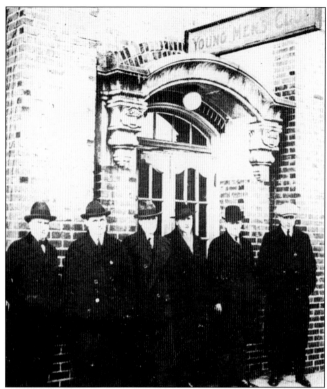

The members of the Young Men's Club, some of whom are pictured here, took part in athletics and cultural events. The men had a band that played throughout Lake County. It was at the request of the Young Men's Club that the Lake Forest Woman's Club undertook responsibility for the first Lake Forest Day. In later years, the Young Men's Club organized the community event themselves. (Courtesy of Lake Forest-Lake Bluff Historical Society.)

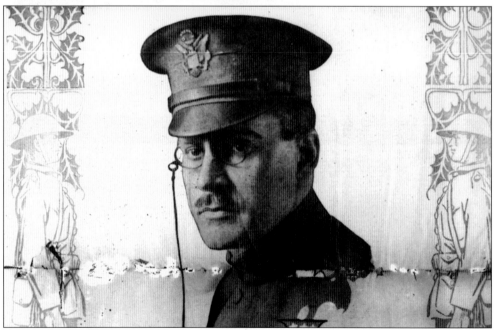

Dr. Theodore S. Proxmire was very instrumental in the establishment of Lake Forest Day. As a member of the Young Men's Club, he went to the Lake Forest Woman's Club with the proposal to put on a community fair. This is a picture of Dr. Proxmire in his World War I uniform in 1918. (Courtesy of Lake Forest-Lake Bluff Historical Society.)

John Griffith started his real estate business in 1903. He was instrumental in the construction of Market Square. His company, Griffith, Grant and Lackie, has been operating in the same location on Western Avenue since 1916. Griffith was among the businessmen who helped the Lake Forest Woman's Club organize the first Lake Forest Day. He also provided meeting space for the Young Men's Club before the group built a permanent clubhouse. (Courtesy of Lake Forest-Lake Bluff Historical Society.)

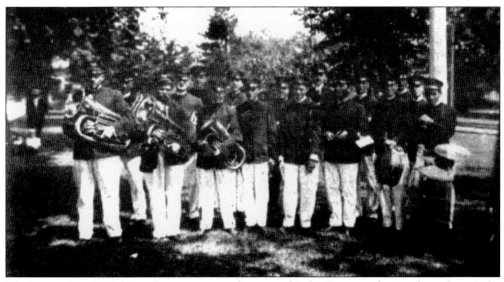

The Young Men's Club band was very popular around Lake Forest and even throughout Lake County. They marched in parades and played concerts. They also played for the Lake Forest Day dances. Dr. Proxmire helped organize the band. (Courtesy of Pioneer Press © 2008.)

The Young Men's Club clubhouse was designed by architect Howard Van Doren Shaw concurrently with his design of Market Square. It was built in 1916–1917 on Forest Avenue, just west of Market Square. When the Young Men's Club disbanded, the building was used by the city recreation department and later housed shops, including Krafft's Drugstore and Lake Forest Jewelers. (Courtesy of Lake Forest-Lake Bluff Historical Society.)

This bridge connected the rooms of the YWCA on the second floor of the First National Bank of Lake Forest building (later Marshall Field's) on Bank Lane on the west end of Market Square with the Young Men's Club gymnasium, directly to the west. The bridge, shown here, is closed, however the alley between the two buildings is used today for outdoor market stalls during the summer months. (Courtesy of Lake Forest-Lake Bluff Historical Society.)

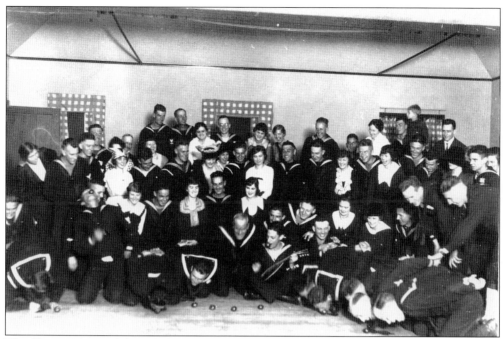

The Young Men's Club and the YWCA shared activities, such as this joint party in 1917. The YWCA also used the men's gymnasium. The YWCA met in the space above the First National Bank Building on the western edge of Market Square, directly behind the Young Men's Club building. A second story bridge joined the two buildings so the YWCA could access the gymnasium. (Courtesy of Lake Forest-Lake Bluff Historical Society.)

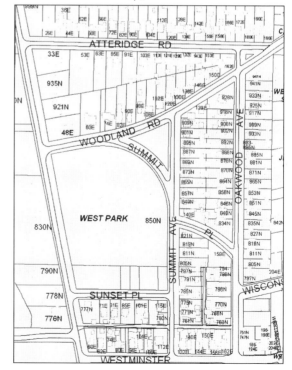

The West Park subdivision, located east of Green Bay Road, was developed by the Young Men's Club as a way to raise funds for a clubhouse. Originally the lots were sold only to club members. An area was set aside and sold to the City of Lake Forest for a public park, appropriately named West Park, as it was on the western edge of the city. (Courtesy of Lake Forest-Lake Bluff Historical Society.)

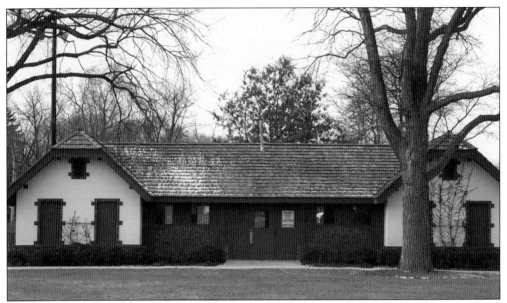

The warming house at West Park was built around 1910 when the subdivision was developed. The building was designed by Pond and Pond. It has been used as a warming house for the skaters using the man-made rink at the south end of the park. (Courtesy of Lake Forest-Lake Bluff Historical Society.)

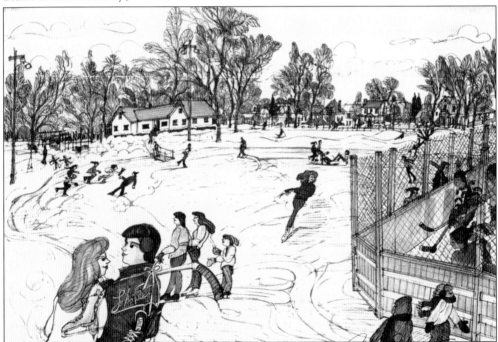

Well-known Lake Forest artist Franklin McMahon drew this scene of the skaters at West Park. McMahon and his son Mark have used their distinctive style to record numerous local scenes and activities. Their work can be found in many museums and galleries. Franklin was one of only two courtroom sketch artists at the trial of the accused murderers of Emmett Till. (Courtesy of the McMahon family.)

Five

AMERICAN LEGION
McKINLOCK POST 264

The American Legion was chartered by Congress in 1919 as a patriotic, wartime veterans' organization devoted to mutual helpfulness. In the autumn of that same year, Lake Foresters established their own veterans' service organization in honor of George Alexander McKinlock Jr., a young Lake Forest man and Harvard graduate who was killed in action in France at the age of 25. An organizational meeting of a group of charter members of the Lake Forest group was held in John Griffith's real estate office.

The George Alexander McKinlock Jr. Post 264 was chartered on October 28, 1919. In the early years, a permanent location was difficult to find. In addition to the offices of John Griffith, Post 264 met in the Anderson Building, the Young Men's Club, the Old Meeting House (which was the old North Western Railroad depot), and the Lake Forest Library. By 1934, the Legionnaires began negotiations to purchase their current building. Initially located roughly where the fountain now stands in Market Square, this building had been moved to 801 North McKinley Road. The building was remodeled by architects Anderson and Tichnor and was formally dedicated on May 26, 1935.

Lake Forest American Legion Post 264 has devoted itself to the service of the community. Its mission is to promote loyalty to country and patriotism, not only in times of conflict, but in peace times as well. The American Legion's flag posting program teaches respect for the American flag. Among their outstanding contributions to the people of Lake Forest are memorial trees on Deerpath, funding the Boy and Girl Scouts, funding the Lake Forest High School Band, college scholarships, and Memorial Day and Veterans Day ceremonies. Lake Forest Day, the most significant annual celebration in Lake Forest, has been sponsored by Post 264 since 1921. It is the main fund-raiser for the American Legion.

The group is supported by the American Legion Auxiliary, whose members consist of mothers, wives, daughters, sisters and other female relatives of members of the American Legion. The American Legion Auxiliary was formed in 1922 at the urging of Marion McKinlock, the mother of George Alexander McKinlock.

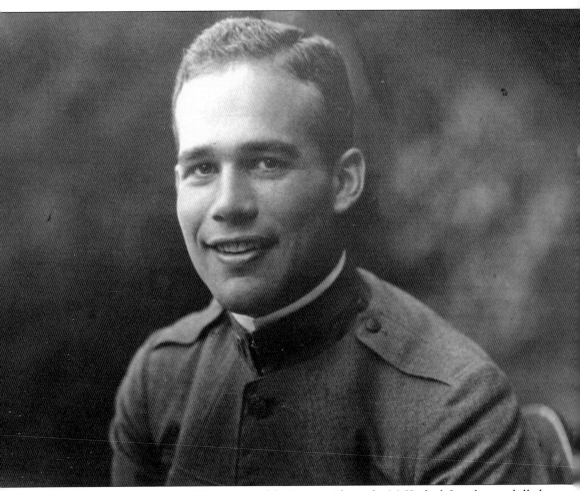

The American Legion Post 264 was named for George Alexander McKinlock Jr., who was killed in action during World War I. Alexander, as he preferred to be called, was born in Chicago in 1893 and graduated from Harvard University in 1916. He worked with his father's business, Central Electric Company, until the war broke out. He was admitted to the First Officer's Training Camp at Fort Sheridan and was commissioned a lieutenant in the United States Army. Upon his arrival overseas, he was assigned to the 3rd Machine Gun Battalion of the First Division as an intelligence officer. He was killed during the Aisne-Marne battle in France. Alexander was awarded the Croix de Guerre with Palm for gallantry and the Distinguished Service Cross for heroism. He was the first of 16 Lake Foresters killed in World War I. His grief-stricken parents, George Sr. and Marion, inaugurated a golf event for World War I veterans at Onwentsia Club and donated money to have their son's dormitory at Harvard University named in his honor. (Courtesy of Lake Forest-Lake Bluff Historical Society.)

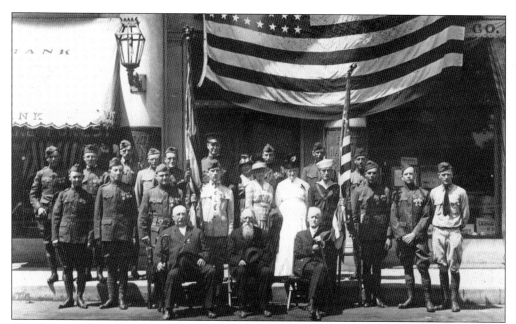

The George Alexander McKinlock Jr. post of the American Legion was formed in 1919. The veterans in this photograph are part of the first group to work on the Lake Forest Day celebration in 1921. This picture was taken during their Memorial Day observance. The first national celebration of Memorial Day (originally called Decoration Day) took place in 1868 at Arlington National Cemetery. (Courtesy of Lake Forest-Lake Bluff Historical Society.)

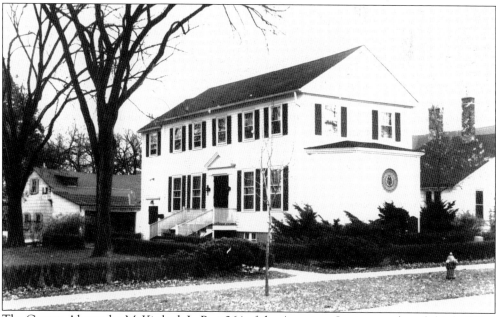

The George Alexander McKinlock Jr. Post 264 of the American Legion purchased this building in 1934 as their headquarters and meeting hall. The building had been previously moved from Western Avenue and stood approximately where the Market Square Fountain stands. The building was remodeled in its present location of 801 North McKinley Road by architects Anderson and Tichnor. (Courtesy of Lake Forest-Lake Bluff Historical Society.)

The American Legion logo was featured in the *Lake Forester* every year to advertise the Lake Forest Day festivities. This one appeared in 1978. (Courtesy of Pioneer Press © 2008.)

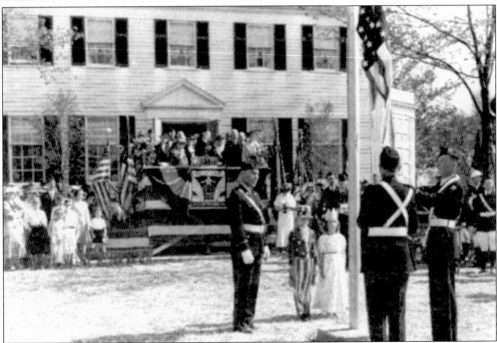

The flagpole in front of the American Legion Hall was dedicated with a solemn ceremony before the Lake Forest Day parade. Children, as well as other community members, participated in the ceremony with members of the American Legion. (Courtesy of the American Legion Post 264.)

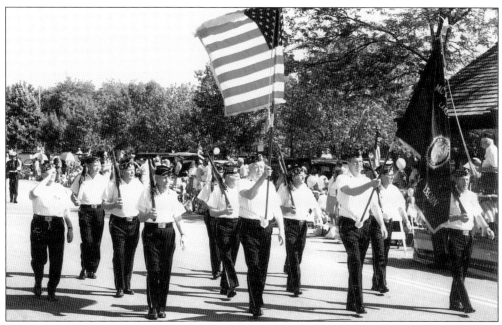

The American Legion color guard has been featured in every parade since 1921. They also march in the Lake Bluff Fourth of July parade and conduct solemn ceremonies on patriotic holidays. Al Glover is shown carrying the American flag. He was instrumental in starting the merchants' flag program. (Courtesy of Roger and Pauline Mohr.)

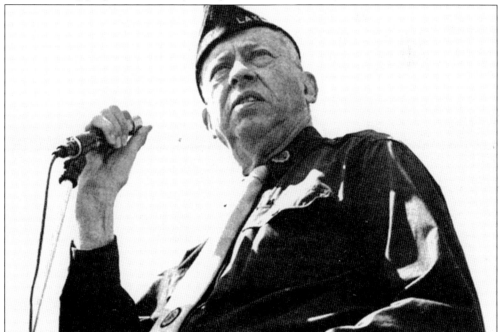

L. Ellsworth Laflin Jr. was the master of ceremonies for many years and is pictured here in that role in 1966. He was popular with the audience, who looked forward to seeing him every year. Laflin was a long time member and former post commander of the American Legion. (Courtesy of Pioneer Press © 2008.)

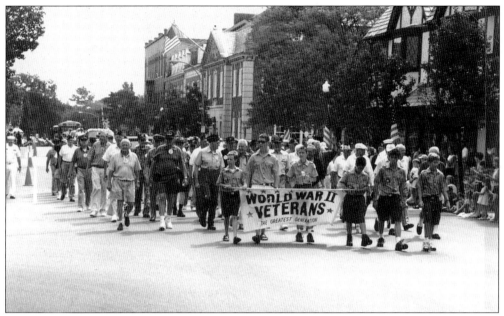

The American Legion chose the theme "World War II Veterans" in 2002. Most of the veterans shown here marching in the parade were members of the American Legion. During this Lake Forest Day, merchants displayed posters about local residents who served in the armed forces during the war. The local newspaper, the *Lake Forester*, also ran a special series of stories about men and women who served the country. (Courtesy of Roger and Pauline Mohr.)

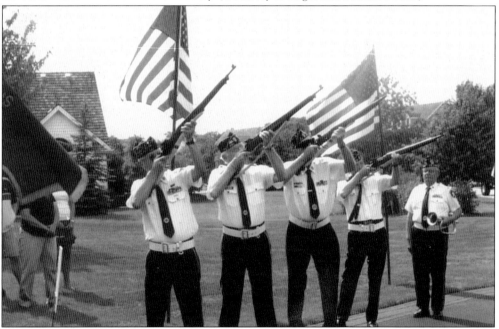

Pictured here in 2005, the American Legion Post 264 Rifle Squad are rendering honors to 2nd Lt. Matt Coutu, a local man killed in the war in Iraq. From left to right, the men of the Rifle Squad are Col. Allan Champ (U.S. Army, retired), Bill Malich, Ed Smith, David Nash, and Larry Crone, the color guard commander. (Courtesy of Judy and Bud Turner.)

Veteran Lou Smith proudly takes his place in the parade line in a year when veterans were saluted. The nation is proud of the veterans and the American Legion. All Americans owe a big thank-you to them for their sacrifice for the United States. (Courtesy of Roger Mohr.)

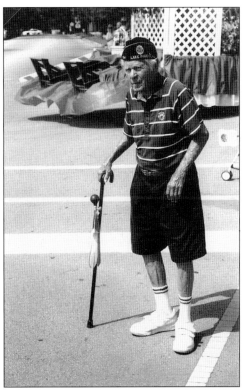

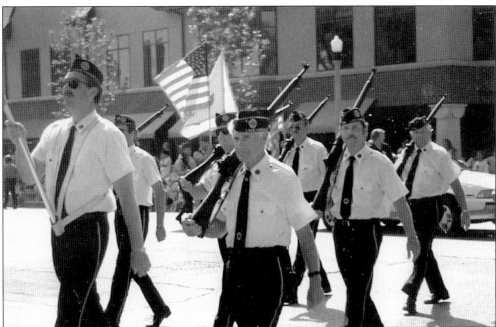

Promoting patriotism is an important mission of the American Legion. Veterans who have served during wartime are eligible for membership in the organization. A community service organization, the American Legion has nearly 15,000 posts worldwide with almost three million members. (Courtesy of the American Legion McKinlock Post 264.)

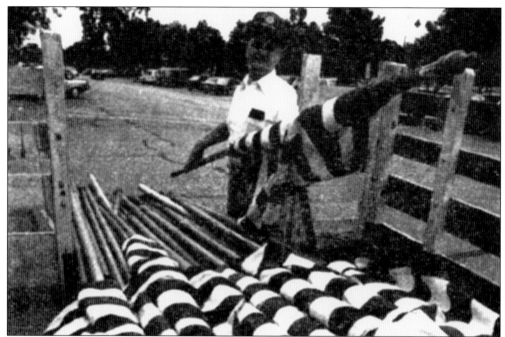

Larry Crone of the American Legion McKinlock Post 264 unloaded flags from his truck. Each year on Lake Forest Day, the American Legion puts flags along the parade route on Western Avenue, by the train station and around Market Square. Over 500 flags are used as a show of patriotism. (Courtesy of Pioneer Press © 2008.)

This photograph, taken in 1976, highlights the flag decoration program that is a hallmark of the American Legion McKinlock Post 264. The American Legion decorates Market Square, and sometimes Western Avenue, for a number of holidays and observances during the year including Memorial Day, Lake Forest Day, Flag Day, and September 11. During Memorial Day, they also place flags at the local cemeteries. (Courtesy of Larry Crone.)

Six

THE RISE, AND FALL, AND RISE OF THE PARADE

The Lake Forest Day parade has had its ups and downs throughout the years. The original plan in 1908 called for a parade, but the Lake Forest Woman's Club, city officials, and the businessmen involved decided that it was not possible at that time. The parades did not start until the second decade of the 20th century. They were held for two or three years. Then Lake Forest Day was canceled for two years because of World War I. The parades resumed in 1923, two years after the American Legion started planning Lake Forest Day. In 1925, three firecrackers were set off to announce the start of the parade. From 1929 to 1939, no parades were held, partly because of the Depression. By 1940, the parades resumed. During World War II, the parades followed patriotic themes.

A very special parade was held in 1955 to honor 50 years of medical service by Dr. Theodore S. Proxmire. The babies that Dr. Proxmire delivered, some of them middle-aged at that time, paraded together with balloons in their hands. Dr. Proxmire had delivered over 3,000 babies during the 50 years and hundreds showed up for the parade.

The tradition continues with plans for an expanded parade during the 2008 centennial year. Former astronaut and Lake Forest resident James Lovell is set to be the parade marshal.

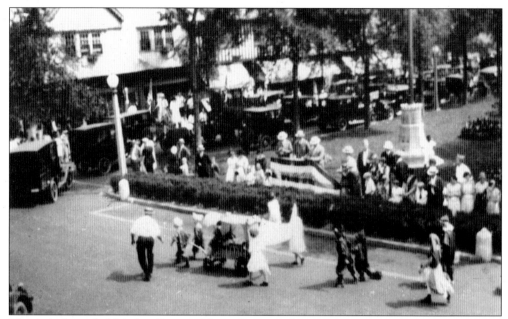

This parade circled Market Square. The judges' stand was right in front for the best view of all the entries. Entries were judged in different divisions including commercial, children, and community. Trophies and other prizes were handed out to the winners. Market Square, one of the nation's first planned shopping centers, became the center of the community when it was built in 1916. (Courtesy of Lake Forest College.)

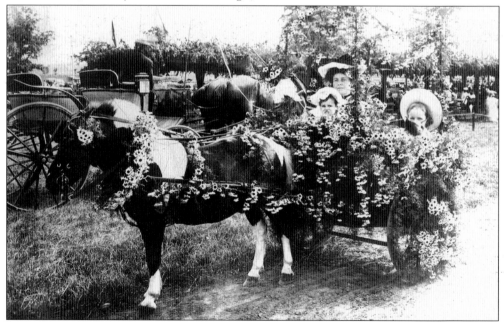

The Durand family made important contributions to the early development of Lake Forest College. Included among these was the donation of funds for Durand Hall. Pictured here with Daisy Durand Smith are her children Durand and Daisiana, with their decorated pony and cart. (Courtesy of Lake Forest-Lake Bluff Historical Society.)

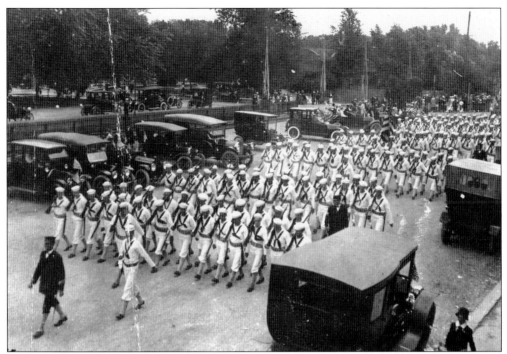

Great Lakes Naval Training Center has sent their young sailors to march in the parades over the years. This group thrilled the crowd in 1915. They were preparing to go overseas during World War I. The Great Lakes Naval Station is still training young sailors today. (Courtesy of Chris Johnson/Spellman family.)

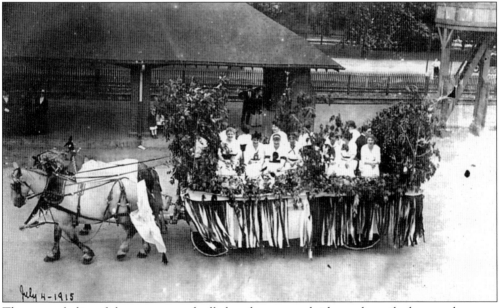

The young ladies of the town were thrilled to dress up and ride on the gaily decorated wagons in 1915. The different merchants, organizations, community, and family groups worked hard to have the most beautiful float. Local gardens were raided for flowers and greenery to use for decorations. (Courtesy of Chris Johnson/Spellman family.)

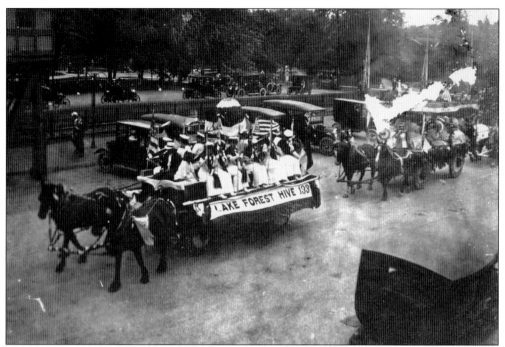

The Hive of Lake Forest, along with other clubs, decorated a wagon for its lovely ladies in white to ride on. The Hive was an auxiliary group of the Society of Macabees. (Courtesy of Chris Johnson/Spellman family.)

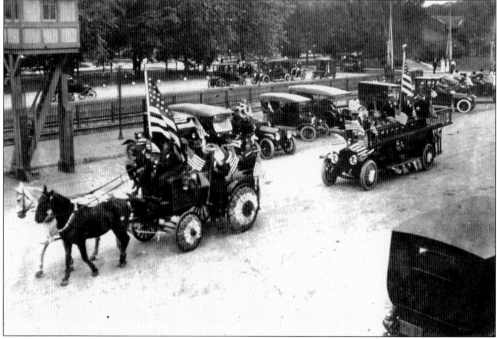

In 1915, the annual Lake Forest Day parade featured many types of vehicles such as beautifully decorated wagons, carriages, automobiles, trucks, and buses. The vehicles were decorated with bunting, ribbons, and flowers. (Courtesy of Chris Johnson/Spellman family.)

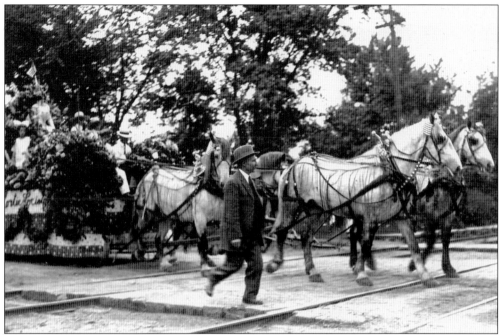

This 1915 float was put together by the North Shore Horticultural Society. The group, organized in Lake Forest in 1905, was composed of gardeners from the area estates. They promoted the idea of beautiful landscaping and shared scientific knowledge about plants. In this photograph, Alexander Allen, who worked on the Laflin estate, marched along with the float as it crossed the railroad tracks. (Courtesy of Chris Johnson/Spellman.)

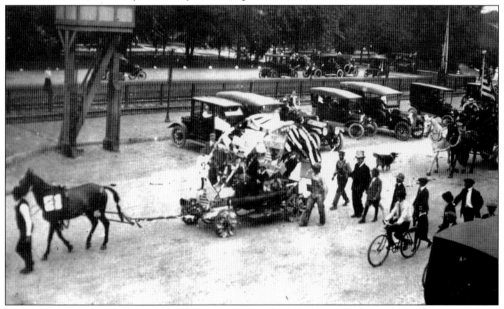

The old saying "get a horse" fit the situation in this photograph. The decorated automobile broke down in the middle of the parade route. A horse was found to pull the float, much to the amusement of the onlookers enjoying the parade on Western Avenue. (Courtesy of Chris Johnson/Spellman family.)

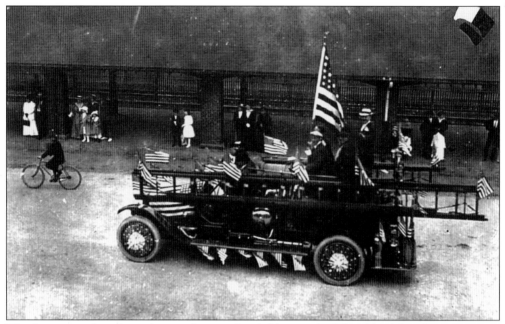

The fire engine has always been a favorite for children and adults alike. This fire engine was featured in the 1915 parade and is shown on Western Avenue by the railroad station. Today fire engines and police cars start and end the parade with their sirens blaring. (Courtesy of Chris Johnson/ Spellman family.)

The family of John and Marie Spellman decorated a bus for the 1915 Lake Forest Day parade. John Spellman was a chairman of the Lake County Republican Central Committee and a real estate dealer. (Courtesy of Chris Johnson/Spellman family.)

Despite the fact that students are not in session during the August Lake Forest Days, Lake Forest College has participated several times over the years, including entering this float in the 1960s. The college played a critical part in the early years of the celebration, when the festivities were held at Farwell Field on the Lake Forest College campus. (Courtesy of the Swanton/O'Neill family.)

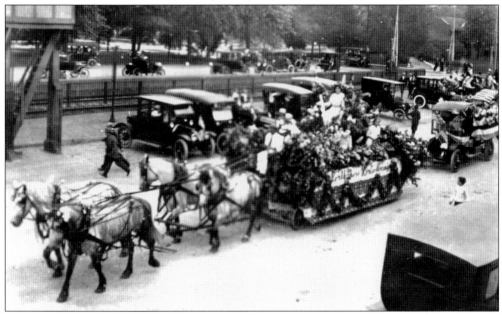

The North Shore Horticultural Society had a large flower show twice a year. They sponsored trips to famous gardens and greenhouses and raised money to support Farwell Field, West Park, and Deer Path Golf Course, among other causes. In 1915, when this float was shown, the society gathered sorrel seeds for drought-stricken Luxembourg. The sorrel leaves were easy to grow and were used in soups and salads. (Courtesy of Chris Johnson/Spellman.)

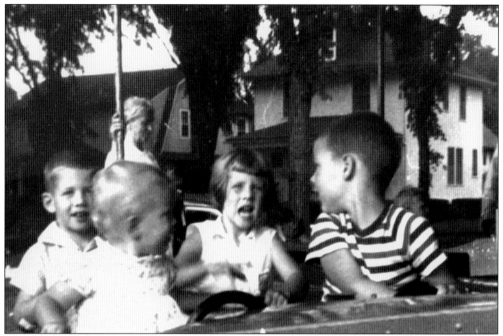

Roger Petersen (at the wheel) and his sister Neila (in the front seat) ride in the parade with two of their young friends. (Courtesy of Roger Petersen.)

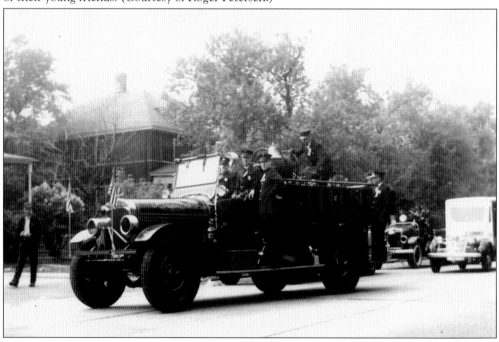

This volunteer group of firefighters led the parade in 1939 in a fire engine. The volunteer fire department was organized in 1893 to "protect the life, safety and property of local residents." The first fire brigade was led by Chief William J. O'Neill Sr., Assistant Chief Claude Crippen, and Capt. Fred J. Wenban. The fire station was housed in the city hall for many years. (Courtesy of Lake Forest-Lake Bluff Historical Society.)

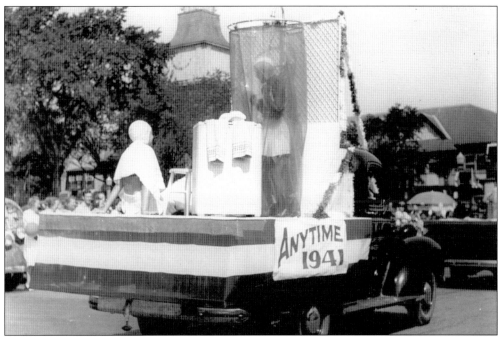

In 1941, the YWCA put together this humorous float for the parade showing a young lady showering after exercising at the gymnasium. The Lake Forest YWCA was organized in 1911 and met in the Red Bird Cottage on the Aldis compound. During the world wars, they organized Red Cross activities, sponsored dances for the area servicemen and hosted USO shows. The group also provides scholarships to Lake Forest College students. (Courtesy of Lake Forest College.)

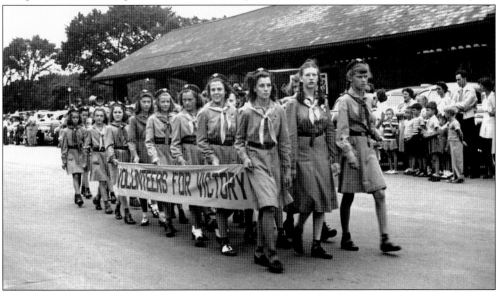

The Lake Forest Girl Scout Troop paraded past the railroad station in 1942. At the time, they were called the "Volunteers for Victory." During the war years, all the themes were patriotic, giving support to the fighting men overseas. Residents in Lake Forest had many ways of supporting the troops such as selling war bonds and collecting scrap metal. Local residents also opened their homes to soldiers stationed at nearby Fort Sheridan. (Courtesy of Jean Grost.)

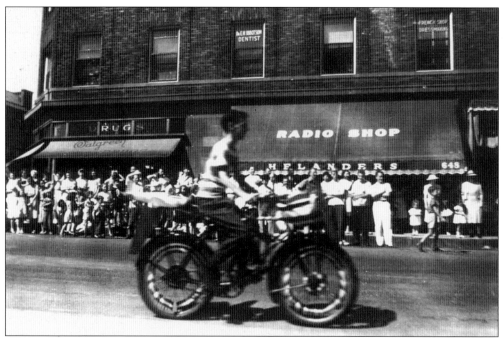

Don Kinney rode his decorated bicycle in the 1944 parade. Seen in the background is the Anderson Building. Walgreens Drug Store is on the left. The Helander family owned Helander's, a radio and music shop seen behind the bicycle. The family sold the radio portion of their business in 1947 to focus their efforts on the stationery store of the same name. (Courtesy of Lake Forest-Lake Bluff Historical Society.)

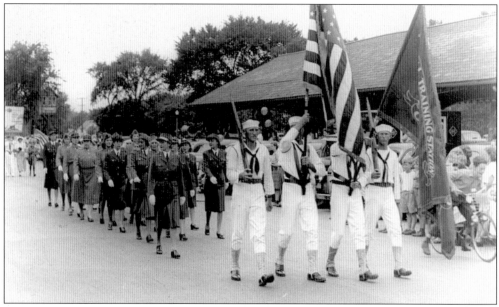

A woman's unit from Great Lakes Naval Training Center march behind the color guard in 1944. The military was being honored in 1944 during the parade with the theme "Prelude to Victory." A number of the marching groups were from the armed services. (Courtesy of Lake Forest College.)

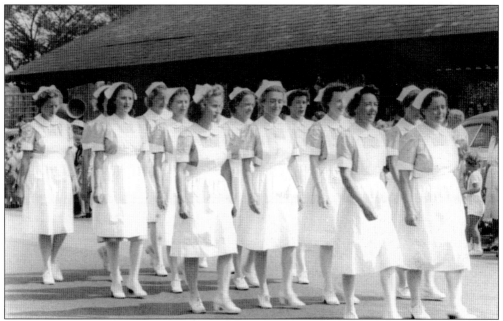

Nurse's aides marched in the 1944 parade along with other patriotic groups. The theme was "Prelude to Victory," as World War II was coming to a close. The nurse's aides came from local hospitals. In 1945, the theme was "On to Tokyo." Only five days after Lake Forest Day was held with this theme, the atomic bomb was dropped on Hiroshima. (Courtesy of Lake Forest College.)

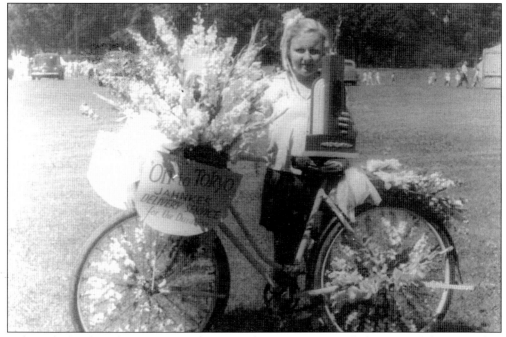

Helen Jahnke's bicycle won a prize this year. She won out over all the automobiles entered in the parade. With flowers from her father's shop, Helen was able to make her bicycle a thing of beauty. (Courtesy of Helen Jahnke.)

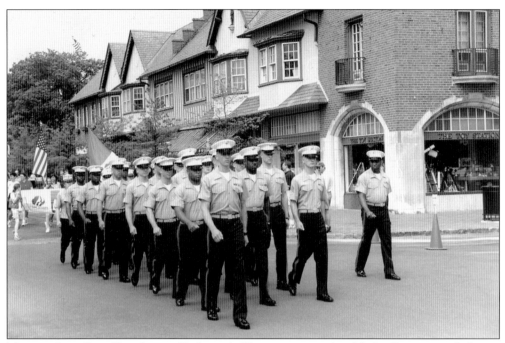

Marines from Fort Sheridan in Highwood, Illinois, just south of Lake Forest, paraded near Market Square. This is one of the many military groups that have marched in the Lake Forest Day parade over the years. (Courtesy of Lake Forest-Lake Bluff Historical Society.)

Helen Jahnke is pictured in 1945, ready to ride the float decorated by her father. Herman Jahnke, a local florist, entered either a float or a decorated car in the parade for many years. His daughter Helen was his favorite passenger. (Courtesy of Helen Jahnke.)

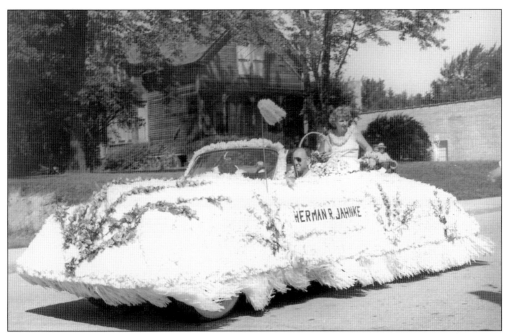

Herman decorated automobiles as well as floats. This automobile, a prime example of his talent, showcased the beautiful flowers from his florist shop. The Herman R. Jahnke Flower Shop operated from 1932 to 1966. It was located at the northeast corner of Market Square, until it moved to 194 East Westminster Road in 1964. (Courtesy of Helen Jahnke.)

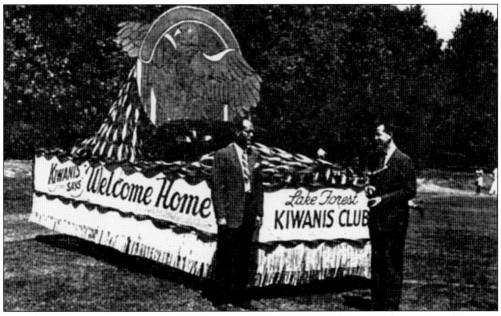

Shown with their entry in 1946, the local Kiwanis Club was a big contributor over the years. The Lake Forest/Lake Bluff Kiwanis Club was established in 1923. One of their goals is to develop future generations of leaders and inspire community service among children and young adults. The local chapter is one of the oldest service clubs in Illinois. (Courtesy of Pioneer Press © 2008.)

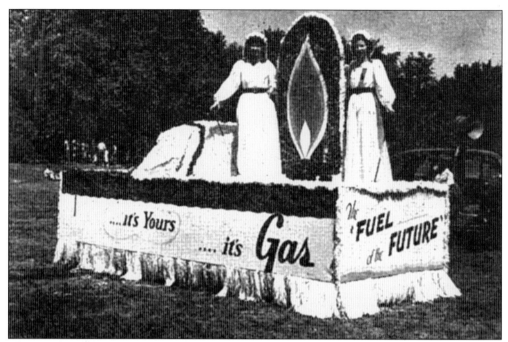

The North Shore Gas Company had several annual entries in the parade, winning trophies for some of them. This 1946 float was one of the company's early entries. Velma (left) and Vera Vanderbloomen appear on this float. The gas company was chartered by the Illinois Legislature in 1849. (Courtesy of Pioneer Press © 2008.)

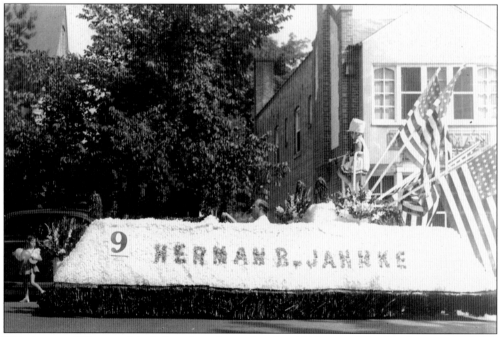

This is one of Herman Jahnke's earliest floats. It is his 1946 entry. The Jahnke name became a familiar one in the Lake Forest Day parades. He was a consistent winner in the commercial division of the parade. (Courtesy of Helen Jahnke.)

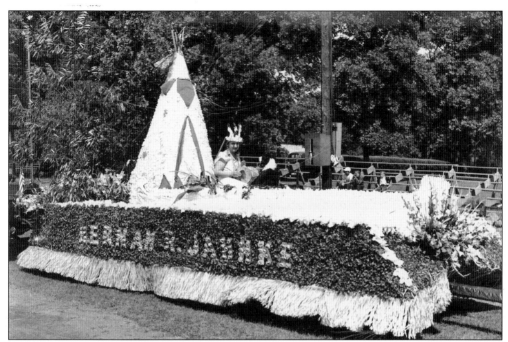

Helen Jahnke rode on her father's award-winning float in 1947. Helen portrayed a Native American squaw sitting outside her tepee. This float was another Herman Jahnke masterpiece. His talent and creativity led to many years of beautiful and innovative floral floats. (Courtesy of Helen Jahnke.)

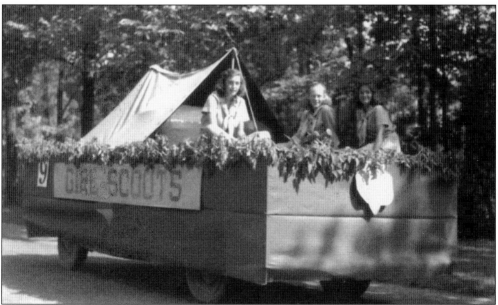

The Girl Scouts recreated the experience of camping in this entry from the 1940s. The Lake Forest troop was organized in 1919 by Lillian Low and by 1945 had grown to 45 members. Local residents Lillian Low Lindenmeyer, Catherine Trowbridge Arpee, and Vivian Campbell Petersen were troop leaders. The American Legion McKinlock Post 264 raises funds each year to support local scouting activities. (Courtesy of Roger Petersen.)

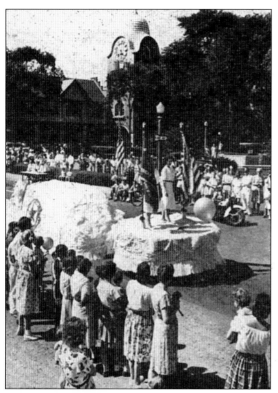

The American Legion Auxiliary entered this float in the 1947 parade. The American Legion Auxiliary, composed of female relatives of American Legion members, has supported the activities of American Legion McKinlock Post 264 since organizing in 1922. The national American Legion Auxiliary is the world's largest women's patriotic service organization with one million members in 10,100 communities. (Courtesy Pioneer Press © 2008.)

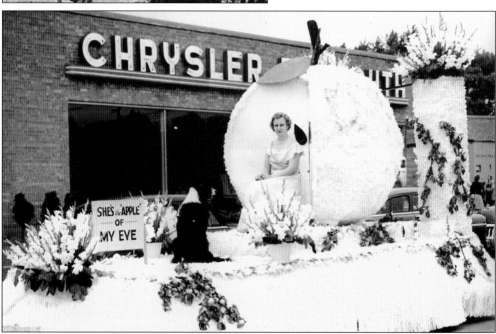

Herman Jahnke, a local florist, entered floats for many years and always featured his daughter Helen. Here she is, the apple of her father's eye, sitting in a large apple surrounded by flowers from her father's shop. This float was in the 1950 parade. In the background is the Chrysler Plymouth showroom that was on north Western Avenue. (Courtesy of Helen Jahnke.)

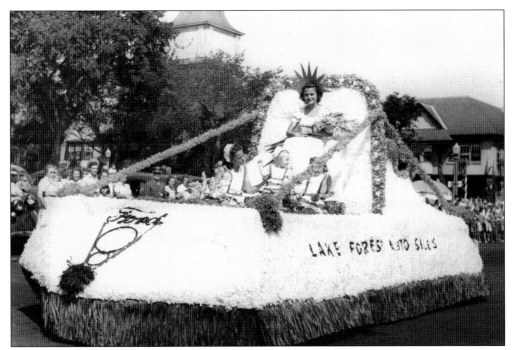

This float was entered by Lake Forest Auto Sales, a local Ford distributor in 1944. The war-related theme was "Prelude to Victory," and the company wanted to show patriotism in this entry. (Courtesy of Lake Forest College.)

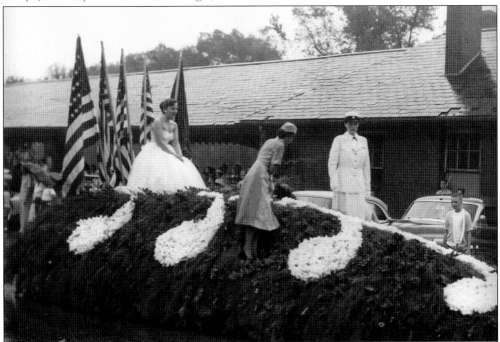

In 1954, Lake Forest Day saluted the veterans' hospitals. Along with Helen, this float featured two women from Downey and Great Lakes Naval Training Station Hospitals in North Chicago, Illinois. (Courtesy of Helen Jahnke.)

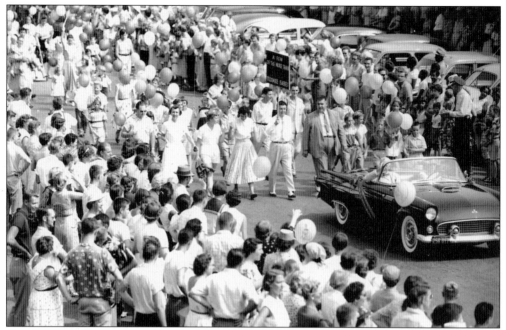

The 1955 Lake Forest Day celebrated beloved physician Dr. Theodore S. Proxmire, who was the grand marshal. Hundreds of men, women, and children who were delivered by Dr. Proxmire marched in the parade carrying balloons. Dr. Proxmire delivered over 3,000 babies during his long career. (Courtesy of Lake Forest-Lake Bluff Historical Society.)

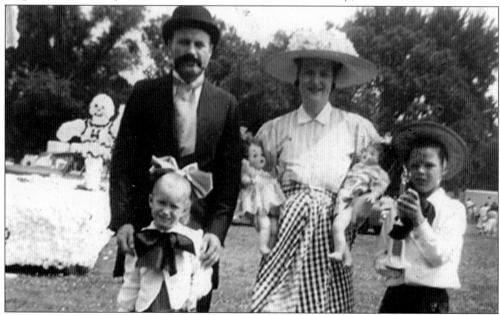

The Petersen family pose in 1956 as they get ready to get in their car. Vivian Petersen, shown here with her husband, Chester, and their two children, Roger and Neila, was the proprietor of Vivian Petersen's Maternity Shop. The family dressed up as the family from *Cheaper by the Dozen*. Other children joined the Petersens in their "jalopy" to fill out the required number of offspring. (Courtesy of Roger Petersen.)

This farm scene of harvest time was featured in the 1956 children's division of the parade. The children, along with some help from their parents, used their imagination to come up with unique ideas in hopes of winning a prize from the judges. (Courtesy of Lake Forest College.)

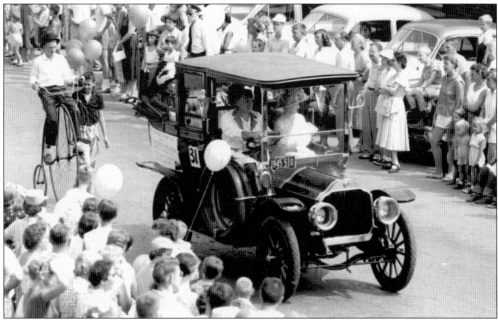

This antique car putts along in the 1956 parade. Behind the car is the famous Kiddle bicycle. Charlie Kiddle rode this high-wheel bicycle in many of the parades. He was a regular feature and the parade watchers would look for him each year. Stanley F. Kiddle owned Kiddle's Bicycle Shop, which was one of the first merchants in Market Square when it was built in 1916–1917. (Courtesy of Lake Forest College.)

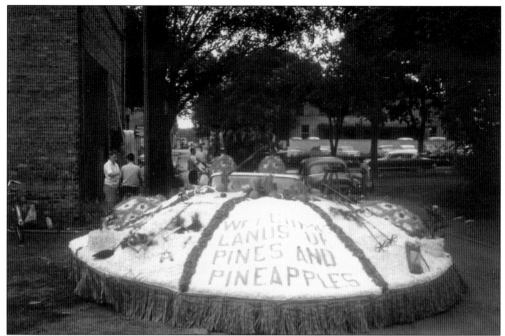

The theme of "Alaska and Hawaii" was chosen for the 1960 celebration in recognition of the recent designation of each of these areas as a state. This float brought attention to the diversity in the flora and fauna of the states, calling them the "lands of pines and pineapples." (Courtesy of David O'Neill.)

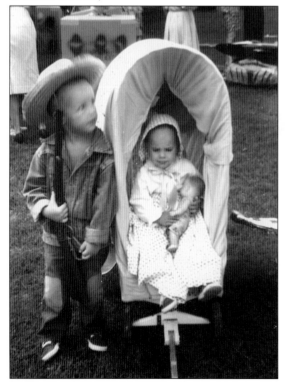

Two young pioneers, David and Peggy Semmelman, appeared in the parade with their covered wagon in the early 1960s. As they grew up, the homemade wooden wagon appeared in other parades in many different forms. (Courtesy of Audrey Semmelman.)

Drew Semmelman was pulled along in the family wagon in 1967. The handmade wood wagon was used by the Semmelman family in all the parades in which they participated. The children were carried, pulled, or marched in the parade every year until they were adults. (Courtesy of Audrey Semmelman.)

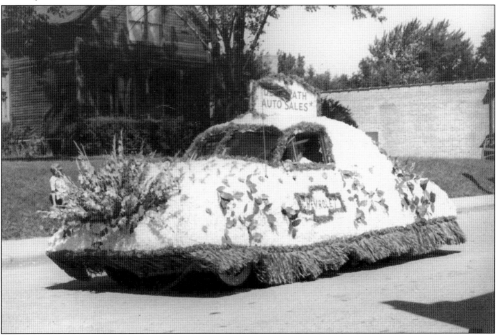

The Chevrolet dealership Deer Path Auto Sales entered this automobile in the parade. The Lake Forest Day parade was a good showcase for local businesses. (Courtesy of Helen Jahnke.)

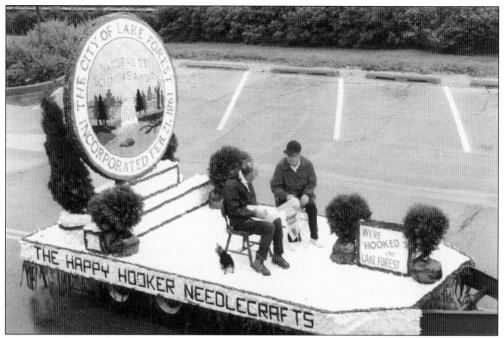

Herman Jahnke is featured on this float. His daughter, Helen, built the float for her needlepoint shop, the Happy Hooker. The logo of the City of Lake Forest was done in needlepoint and, after the parade, was put on display at the Lake Forest City Hall. The Jahnke family entered floats for a number of years and won many trophies for first place. (Courtesy of David O'Neill.)

Part of the parade route was along Deerpath. In the background was the Deerpath Theater, designed by Stanley Anderson, which opened in 1928. It was advertised as the finest on the North Shore. It was equipped with a pipe organ and a talented organist. The featured film for the opening was "Glorious Betsy." Joseph Emma was the manager for nearly all the years of the Deerpath Theater's existence. The theater closed in 1985. The building now has a few shops and offices.

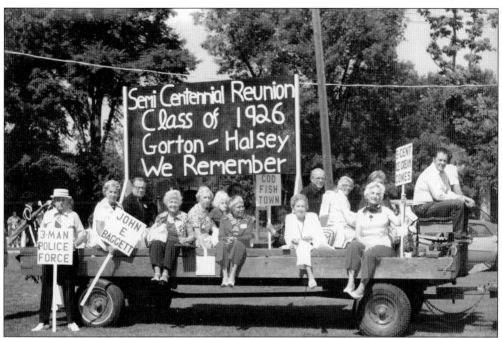

Halsey School and Gorton School were the two public schools in 1908 when the first Lake Forest Day was held. Gorton School was in continuous use from 1880 until 1972, but Halsey School was torn down in 1955. The joint class celebrated its 50th anniversary in 1976. The Gorton building is now a community center. (Courtesy of Lake Forest-Lake Bluff Historical Society.)

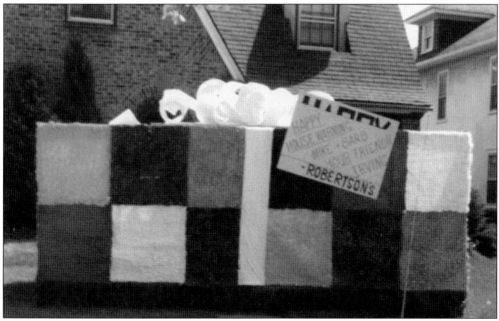

"Happy 200th America" was the theme of this float in 1976, the bicentennial of the United States. The designers wanted to honor America with a big present. This float had double use, however. The present was put on the lawn of a family that had just moved into the house, and it became a housewarming gift. (Courtesy of the Swanton/O'Neill family.)

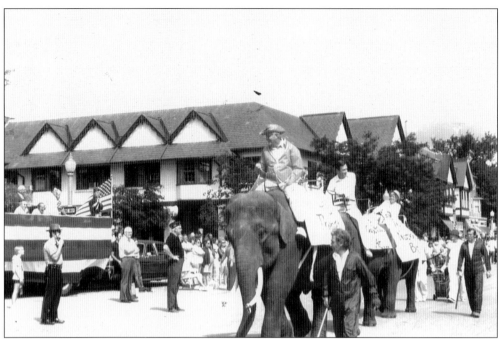

In 1975, the Midwest National Bank (now First Midwest Bank) had a big surprise for the citizens of Lake Forest. Three elephants appeared with three of the bank's employees on their backs. First Midwest National Bank built new offices at 241 East Deerpath in 1976. The design, by Bleck and Bleck, reused an earlier building that had been an A&P grocery store. (Courtesy of Mildred Sorensen.)

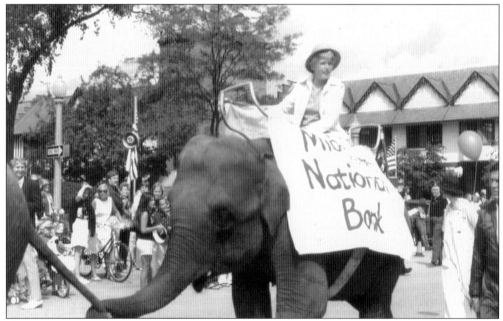

Betty Ann Burns of the Midwest National Bank of Lake Forest rides the end elephant in the 1975 parade. This was a surprise for the onlookers, as the elephants were kept a big secret until the parade day. (Courtesy of Mildred Sorensen.)

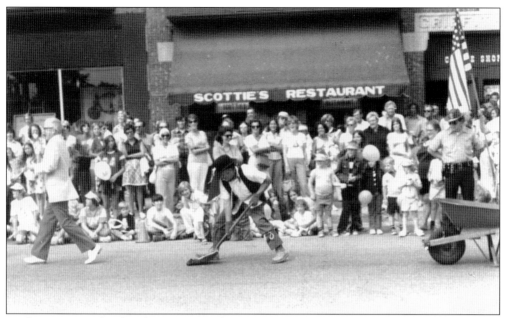

In the 1976 parade, the clean-up crew dressed as clowns. The parade had several groups of horses and other animals, so the clowns had their work cut out for them. (Courtesy of Shirley Paddock.)

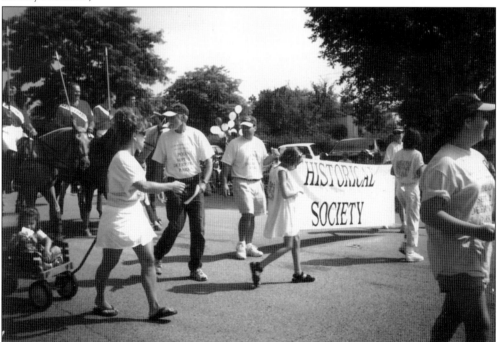

The Lake Forest-Lake Bluff Historical Society marched with polo ponies and riders. Between 2000 and 2006, the historical society sponsored annual polo matches and the Polo Ball. Initially organized by Georgia West, the event was chaired over the years by Molly Rice, Scott Meland, Maureen Tuohy, Jim Tuohy, and Alan Gaitan. They were supported by numerous volunteers and community institutions, among them Elementary School District 67. (Courtesy of Larry Crone.)

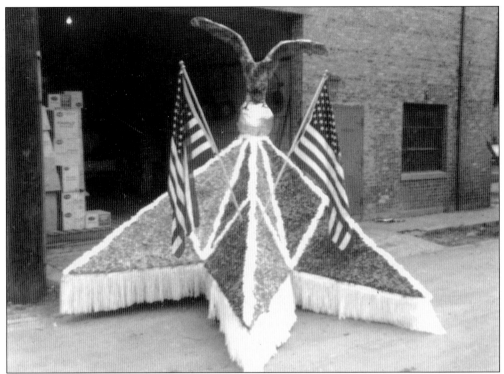

The O'Neill Hardware Store entered this float in the 1961 parade, celebrating the centennial of Lake Forest. David O'Neill designed and built the float. Inspired by the flag, it was star-shaped, colored blue and green, and had a white fringe. It was operated by a manned tractor underneath, who communicated with a guide outside via walkie-talkie. (Courtesy of David O'Neill.)

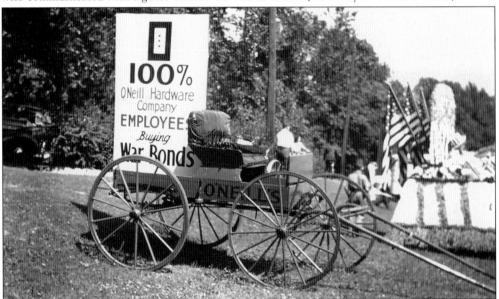

O'Neill's Hardware Store has been an important business since the early days of Lake Forest. The O'Neills helped with the first Lake Forest Day along with other prominent business owners. (Courtesy of David O'Neill.)

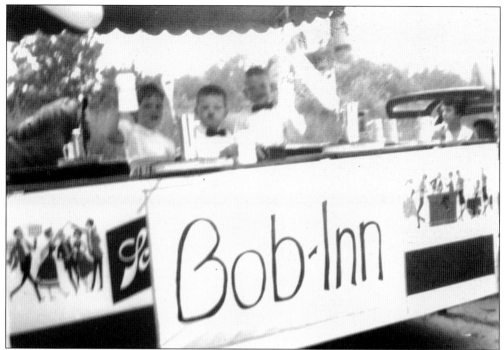

The Bob-Inn, owned by Bob Weston, was a popular local bar located at 724 North Western Avenue. It was in operation during the 1950s and 1960s. Weston had the distinction of serving the first pizza in Lake Forest. On the float, offering a toast to 1960s Lake Forest Day, from left to right, are Pam Weston, Jeff Wageman, and Bob. The parade had to be cancelled that day due to pouring rain. (Courtesy of Kay Kerrigan Weston.)

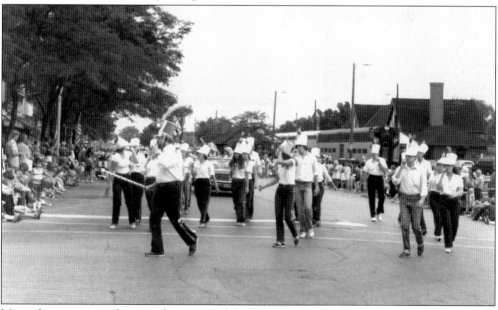

Musical entries over the years have ranged from the more formal military marching bands to groups put together by local residents. In this parade, a group from the community formed a kazoo band to entertain the crowd. (Courtesy Jean Grost.)

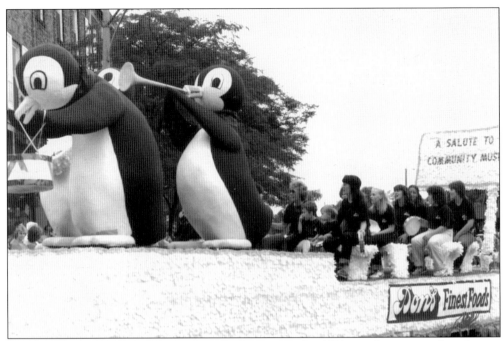

Don's Finest Foods entered these musical penguins in the 1981 parade as part of a salute to community music. Lake Forest has a long tradition of jazz music. The Samuel Dent Memorial Jazz Band began in the late 1960s and continues to play Dixieland-style jazz. The ensemble was begun by Brooks Smith. In 1969, Don Ruffolo purchased Janowitz Finest Foods (which began in 1939), changing the name to reflect the new ownership. (Courtesy of Jean Grost.)

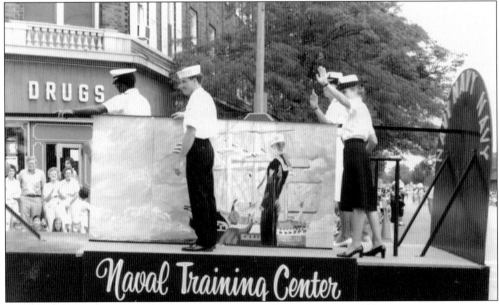

Great Lakes Naval Training Station brought this float for the 1981 parade. Great Lakes Naval Station is located on Lake Michigan between Lake Bluff and North Chicago. It is known as the "Quarterdeck of the Navy" because of its important role as an entry point for personnel. (Courtesy of Jean Grost.)

Clowns entertained the crowd all up and down the parade route in 1981. Clowns have always been favorites of the young and the young at heart as they frolicked around. (Courtesy of Jean Grost.)

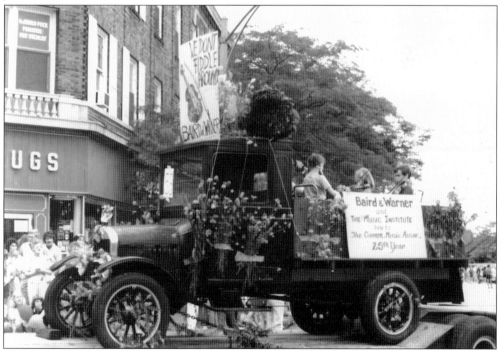

Baird and Warner entered this antique truck in the parade to honor the Music Institute and the Community Music Association. The truck was so antique that it had to be hauled on a flat bed truck. (Courtesy of Jean Grost.)

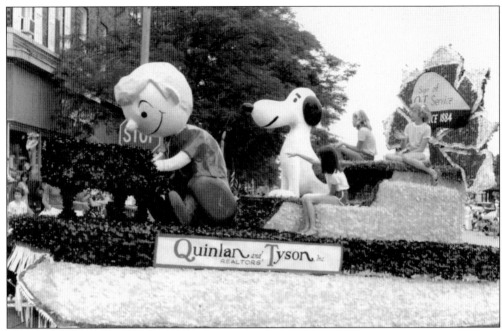

The theme for 1981 was "A Salute to Community Music." On this float for Quinlan and Tyson realtors, Schroeder (from the comic strip *Peanuts*) shows his musical skill to Snoopy. The community is home to the Lake Forest Symphony, the only fully professional orchestra in Lake County. The Lake Forest Symphony celebrated its 50th anniversary in 2008. (Courtesy of Jean Grost.)

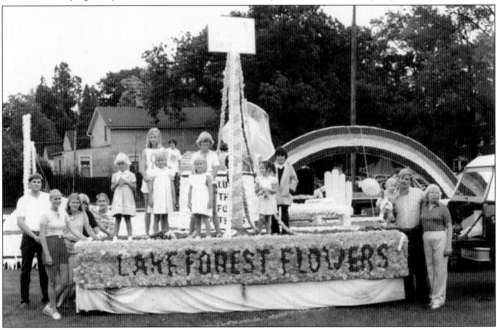

Lake Forest Flowers has served the community since 1979. The florist shop, located at 546 North Western Avenue (at Illinois Road) is owned by the family of John A. Looby III, who entered this float. The shop's location previously housed Grace McGill Flowers, which started in 1947. (Courtesy of John A. Looby III.)

As an alternative to dressing up as popular sports heroes, the Turner kids decided to honor the act of resting in 1984. Corey, Tiffany, and Courtney Turner, as the laid-back Olympic Resting Team, carried off the First Prize in the Children's Parade that year. The float tied in with the 1984 Summer Olympics in Los Angeles. Who ever said hard work is everything? (Courtesy of Judy and Bud Turner.)

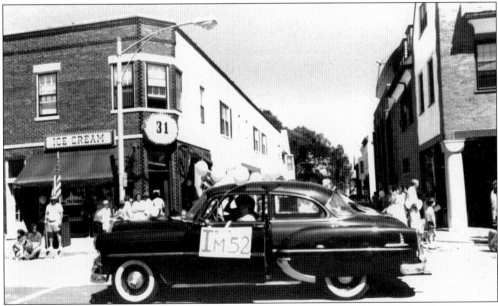

This car declared that it was 52 years old in 1985. Seen at left in the photograph is the Eastwood Building, which held a tavern and then an ice cream parlor. On the second floor of the building, located at the northwest corner of Bank Lane and Deer Path, was Henderson's Bowling Alley. (Courtesy of Jean Grost.)

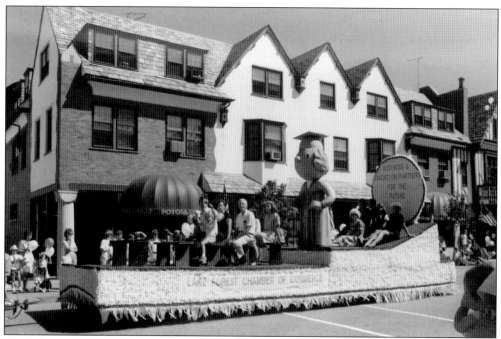

The Lake Forest-Lake Bluff Chamber of Commerce congratulated Lake Forest High School on its 50th anniversary in 1985. High school students attended Deerfield Shields Township High School in Highland Park until the 1930s. A new building opened in 1935 for the students from Lake Forest and Lake Bluff. (Courtesy of Jean Grost.)

The Lake Forest High School class of 1951 held a reunion during the 1985 Lake Forest Day. Many groups, both school and family, held reunions each year centered on the early August event. (Courtesy of Jean Grost.)

74

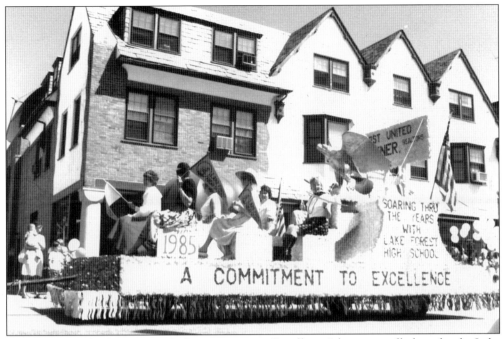

The 1985 parade theme was "A Commitment to Excellence" honoring all the schools. Lake Forest High School students designed and built this float for the parade. Lake Forest High School opened in 1935 and was built on land donated by local residents as a project of the Works Progress Administration (WPA). (Courtesy of Jean Grost.)

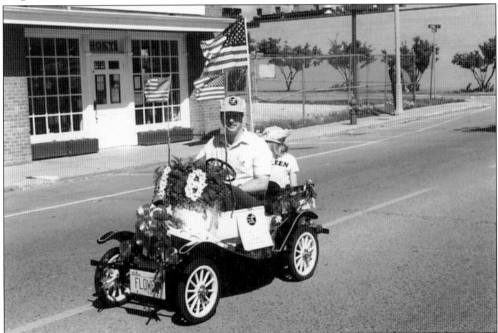

Small cars of all models have been exhibited in the parade over the years. The building located in the background is Wells and Coppithorne Hardware (previously Lake Forest Lumber). The Jewel Grocery store now sits at this location. (Courtesy of Lake Forest-Lake Bluff Historical Society.)

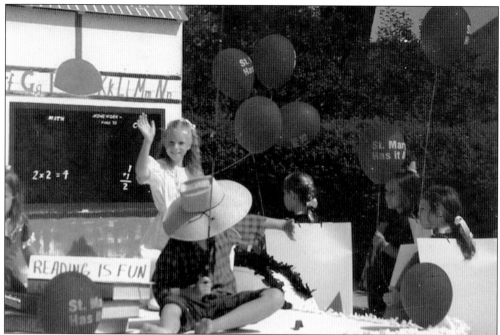

The School of St. Mary celebrated education with this float featuring a classroom with students. The School of St. Mary, connected with the Church of St. Mary, opened in September 1917. To address the expanding Catholic school population, a new primary grade school was built on Everett Road in 1997 as a complement to the school on Illinois Road. (Courtesy of Lake Forest-Lake Bluff Historical Society.)

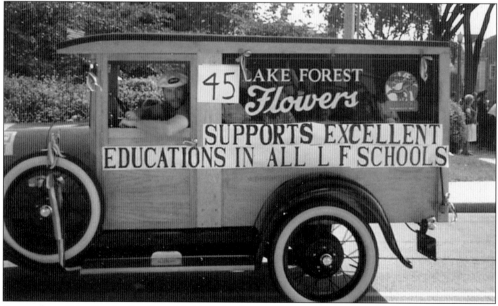

A member of the Looby family, with his Lake Forest Flowers truck, proudly supports the schools of Lake Forest. With a number of public, private, secondary, collegiate, and graduate schools, the industry of education is the largest employer in Lake Forest. The theme of "Education" was chosen many times over the years. (Courtesy of John A. Looby III.)

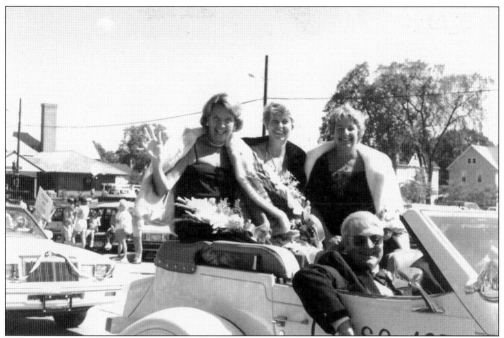

Members of the Lake Forest High School class of 1951 celebrated their 35th reunion in 1986 by riding this car in the parade. The classmates riding in the car, from left to right, are Kay Kerrigan Weston, Ginnie Haake Parker, and Audrey Henriksen Semmelman. (Courtesy of Kay Kerrigan Weston.)

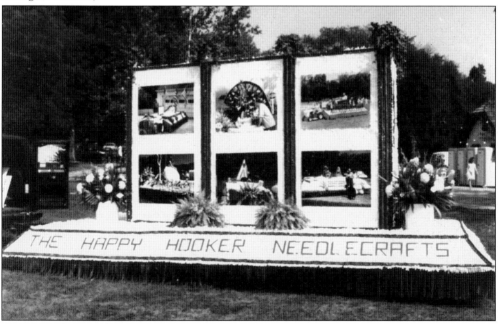

In 1988, Helen Jahnke entered this float representing her business, the Happy Hooker, a popular needlework shop. In recognition of his long involvement in the Lake Forest Day parade, her father, Herman Jahnke, was chosen to be the parade marshal that same year. The Happy Hooker opened in 1973 and was located at 202 Wisconsin Avenue. (Courtesy of Helen Jahnke.)

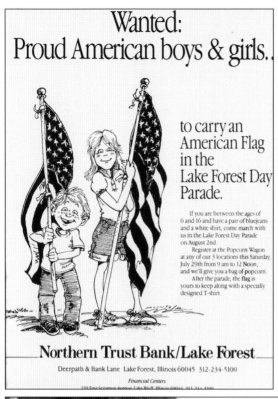

The *Lake Forester* ran this advertisement for the Northern Trust Bank of Lake Forest in July 1989. The bank advertised for children between the ages of 6 and 16 to carry flags in the parade and received a great response. (Courtesy of Pioneer Press © 2008)

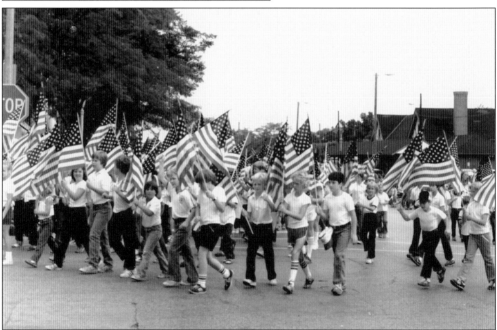

Scores of children from 6 to 16 answered a newspaper advertisement by the Northern Trust Bank to carry flags and march in the parade. The bank celebrated the centennial of its Lake Forest location in 2007. Chartered as the First National Bank of Lake Forest in 1907, the bank became part of the Northern Trust Bank in 1986. (Courtesy of Jean Grost.)

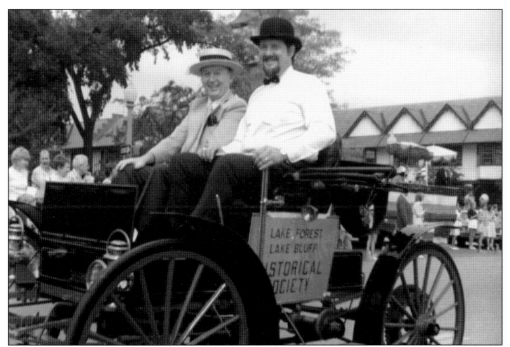

The Lake Forest-Lake Bluff Historical Society entry featured a Sears car driven by its owner Carroll Sears, a descendant of Richard Sears, the founder of Sears, Roebuck and Company. Sears Motor Buggies were built between 1908 and 1912. (Courtesy of Lake Forest-Lake Bluff Historical Society.)

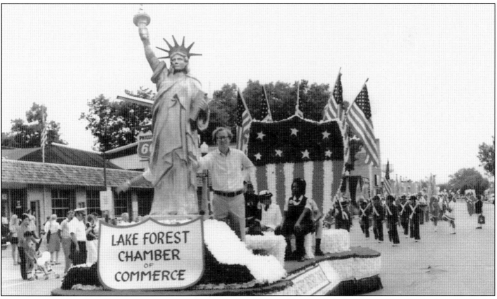

Patriotism was the theme for many of the Lake Forest Day celebrations. The Lake Forest-Lake Bluff Chamber of Commerce built this float to celebrate the theme with the Statue of Liberty as the main feature. The chamber of commerce, located in the former baggage room of the railroad station on Western Avenue sponsors a successful "Shop Local" program to support local merchants. (Courtesy of David O'Neill.)

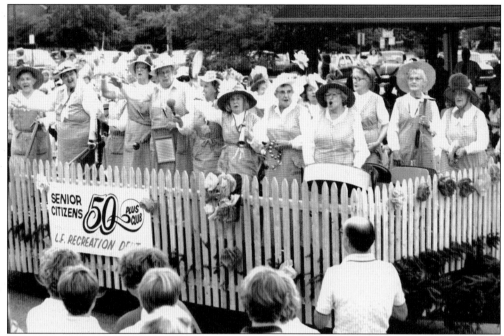

The Senior Center's 50 Plus Club entertains during the parade with their unique musical instruments and their singing. The group is well known at local senior centers, nursing homes, and club meetings. (Courtesy of Lake Forest-Lake Bluff Historical Society.)

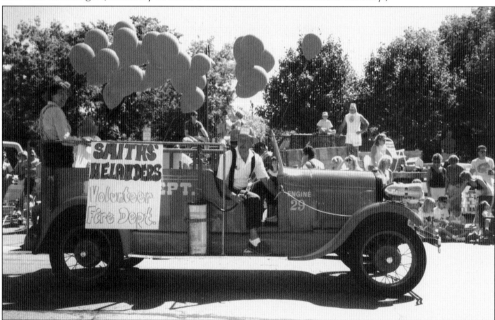

Helander's and Smith's Men's Store worked together to enter this old fire engine in the parade. Axel Helander, who came from Finland, started his shop, Helander's, on Western Avenue in 1916, selling radios, music, and stationery. The business moved to Market Square in 1949, and by then was focusing solely on the stationery business. The business continues to be family-run. (Courtesy of the Smith family.)

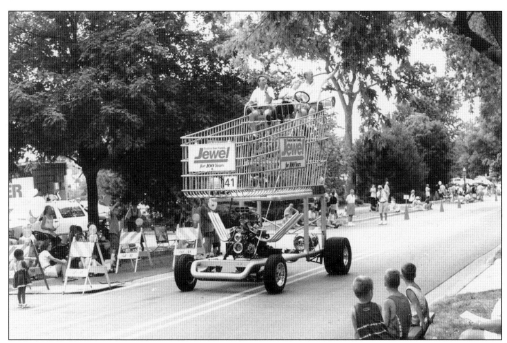

A huge shopping cart sponsored by the Jewel Grocery Store was an amazing feature in the 1993 parade. The cart was self-propelled, with the driver sitting in the "baby" seat. This cart has been in several of the parades since the 1990s. (Courtesy of Jeanne Goldman.)

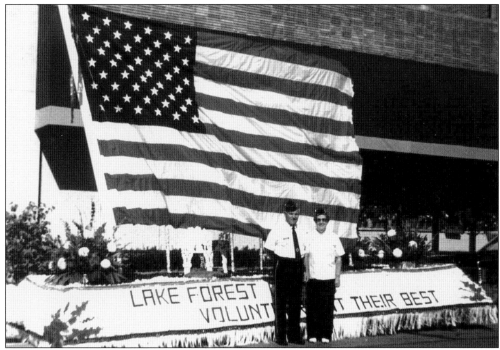

To honor volunteers of Lake Forest in 1990, a giant flag was flown on this float. This striking float, designed by David O'Neill, was featured on the front pages of the local newspapers. The float consisted of a special framework to keep the flag upright. (Courtesy of David O'Neill.)

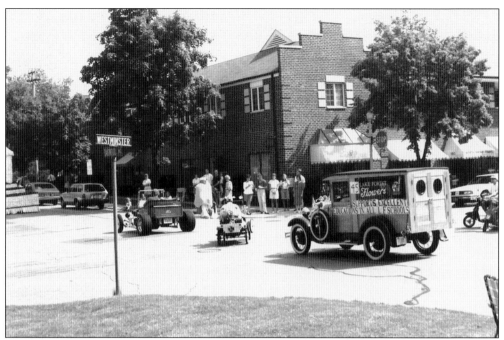

Many Lake Forest residents own restored historic automobiles of all shapes and sizes. They look forward to parading them whenever the chance arises. Lake Forest Day is the perfect opportunity to show off their prized possessions. The Lake Forest Flowers truck was driven by John A. Looby III, owner. (Courtesy of Jeanne Goldman.)

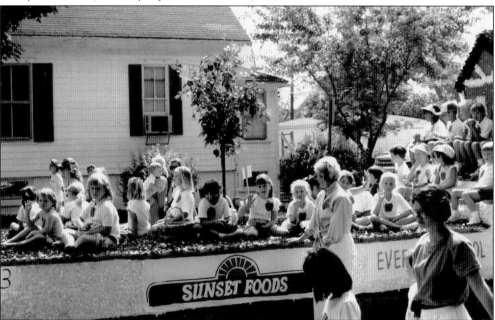

Everett School, under the sponsorship of Sunset Foods, proudly entered this float in the parade. In 1914, Everett School opened at the first of its three locations. Sunset Foods is located in the Pioneer Square shopping center near Waukegan Road and Everett Road. The chain of four groceries began in Highland Park in 1937. (Courtesy of Jeanne Goldman.)

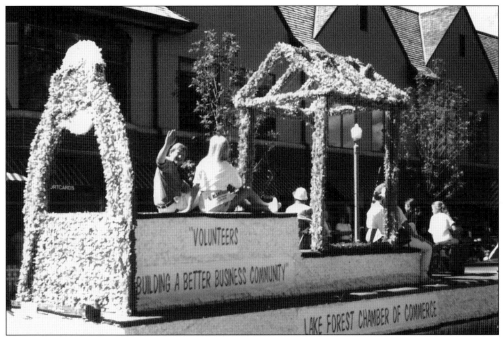

Volunteering in the community was the theme of this Lake Forest-Lake Bluff Chamber of Commerce float in 1992. The Lake Forest Day theme that year was "A Salute to Lake Forest's Unique Spirit." The chamber of commerce celebrated 50 years of service to the community in 2005. (Courtesy of David O'Neill.)

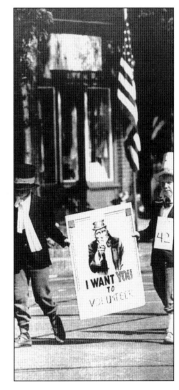

In 1991, Lake Forest volunteers were honored. Many Lake Forest residents, young and old, volunteer at the hospital, in nursing homes, at the recreation department, at the Gorton Community Center, and other places where there is a need. Two young volunteers advertise for additional participation by citizens. (Courtesy of Pioneer Press © 2008.)

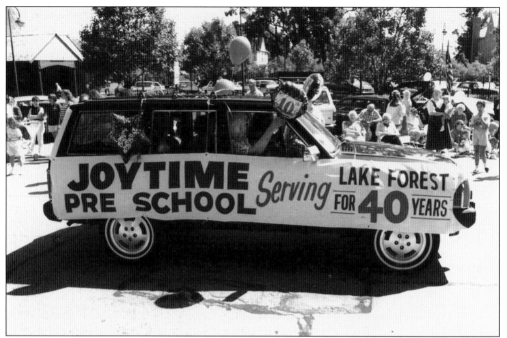

Joy Time Pre School was started in 1953 by Joy Hodgen and her husband, Earl. At the time, both were recent graduates of Lake Forest College, majoring in education. The school served four- and five-year-old children and was located in the Northmoor subdivision. It is now run by their daughter Kathleen Hodgen. (Courtesy of Lake Forest-Lake Bluff Historical Society.)

A wide variety of musical groups have joined the parade during the years. This group of bagpipers from the early 1990s entertained the spectators as they marched along the parade route. (Courtesy of Roger and Pauline Mohr.)

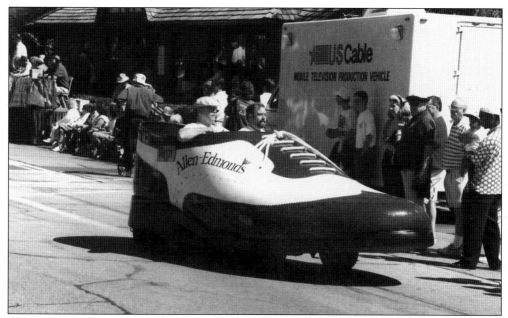

There were many unique vehicles in the parades through the years, such as this one advertising Allen-Edmonds Shoes for men. For much of the century, local merchants were closed on Wednesday afternoons. Lake Forest Day has taken place on a Wednesday each year, giving merchants the freedom to participate fully in the festivities. (Courtesy of Roger and Pauline Mohr.)

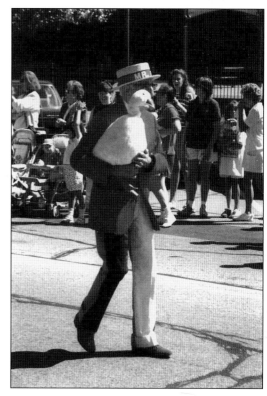

Mother Goose is familiar to all the children, but here was Father Goose marching in the parade in the early 1990s. The goose and his master were heading for the petting zoo, which was set up at West Park. (Courtesy of Roger and Pauline Mohr.)

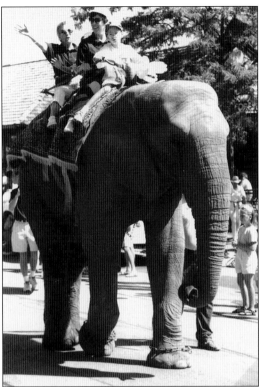

In 1993, this huge elephant made its way along the parade route to West Park. Other non-traditional animals to tread the parade route in recent years have included geese and the local dachshund club. (Courtesy of Roger and Pauline Mohr.)

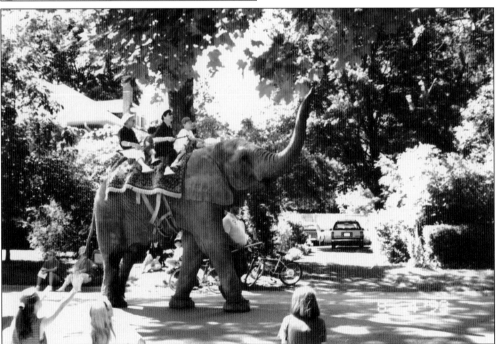

Elephants have been paraded down the streets of Lake Forest at least three times during the years. This one was the showpiece of 1993. Later the elephant was taken to West Park, where a petting zoo was featured. (Courtesy of Jeanne Goldman.)

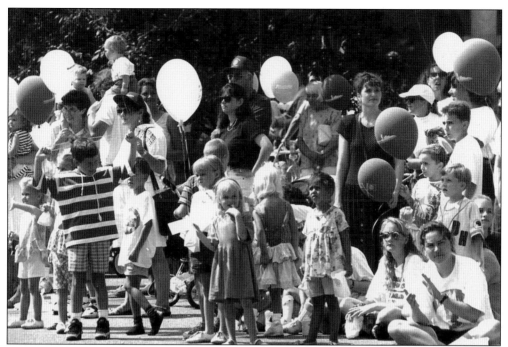

Every year, the parade route is several people deep with spectators. People bring blankets, chairs, or wagons to sit on. The hardier folks stand or sit right on the pavement. Children anxiously wait for handouts during the parade, particularly candy. (Courtesy of Pioneer Press © 2008.)

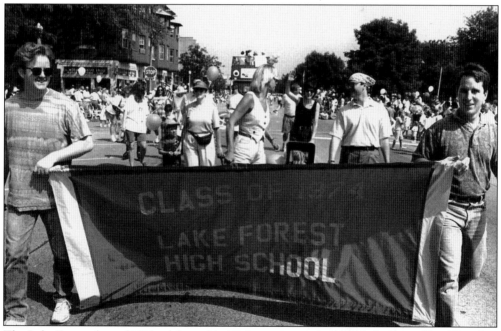

The Lake Forest class of 1974 celebrated its 20th reunion at the 1994 Lake Forest Day. The class reunions for Lake Forest High School are held to coincide with the community celebration. Because of this, many former residents return to town in August for the event. (Courtesy of Pioneer Press © 2008.)

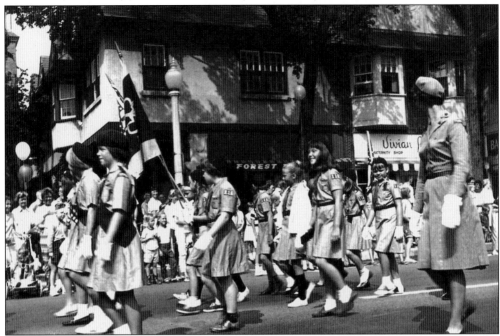

The Scouts organizations either lead or march in the parade every year. This is their group in the 1960s. The American Legion has been a long time supporter of the Boy Scouts, the Girl Scouts, and the Cub Scouts. Some of the proceeds from Lake Forest Day are used for this funding. (Courtesy of Pioneer Press © 2008.)

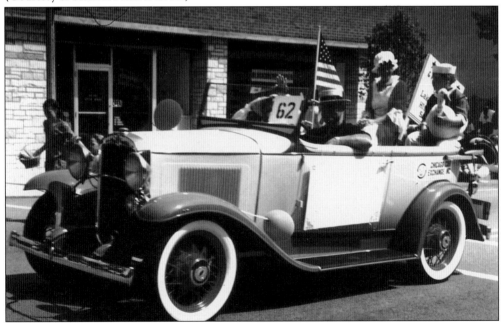

The Lake Forest-Lake Bluff Historical Society, formed in 1972, collects and preserves local history. This car's sign asks for members and volunteers for the historical society. Many citizens rely on the organization, and its archives, to help find information about their home, their family history, and the community. (Courtesy of David O'Neill.)

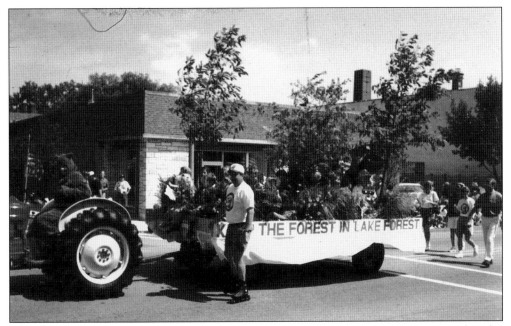

The Lake Forest Open Lands Association, founded in 1967 to preserve open space and native landscapes, works toward keeping Lake Forest green. This float pleads for local residents to "Keep the Forest in Lake Forest." Lake Forest has received the designation as a "Tree City, USA" through the Department of Natural Resources. The program promotes tree planting and care programs in urban areas and calls attention to the economic, health, and aesthetic benefits trees offer. (Courtesy of David O'Neill.)

Mr. Mouse is asking for a home, perhaps in one of the local forest preserves. The Lake Forest Open Lands Association was founded in 1967 and is dedicated to conserving Lake Forest's natural environment through land acquisition, habitat restoration, environmental education, and conservation advocacy. (Courtesy of David O'Neill.)

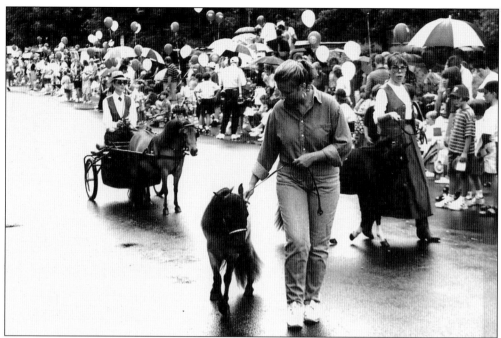

These miniature horses paraded despite the falling rain. Lake Forest Day goes on rain or shine, except for 1960 when there was a huge storm that did considerable damage to the area. During that year, the celebration was postponed until later in the week. Because Lake Forest Day is held on the first Wednesday of August, it is just as likely to be very hot as it is to be stormy. (Courtesy of Roger and Pauline Mohr.)

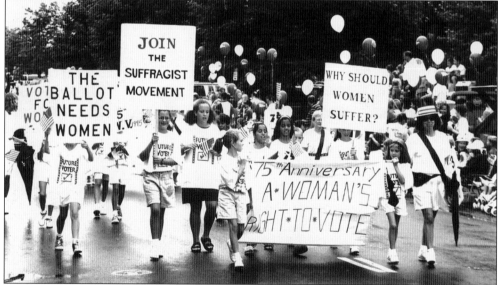

August 1995 marked the 75th anniversary of the ratification of the 19th Amendment to the Constitution. The amendment guarantees all American women the right to vote. Achieving this milestone required a lengthy struggle, one in which the Lake Forest Woman's Club stayed informed with speakers on the topic. When the women organized the first Lake Forest Day, they were still 12 years away from being able to vote. (Courtesy of Roger and Pauline Mohr.)

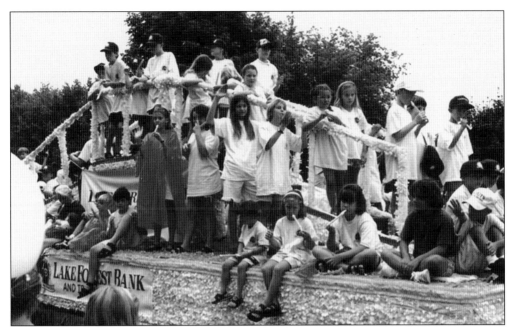

Lake Forest Bank used the children of the town for their 1995 float. Lake Forest Bank was founded in 1991. By 1999, they had drawn up plans for the Market North project, which redeveloped the block of Westminster Road between Bank Lane and Western Avenue and included space for the bank. The development was carefully built to fit in with Howard Van Doren Shaw's Market Square. (Courtesy of Roger and Pauline Mohr.)

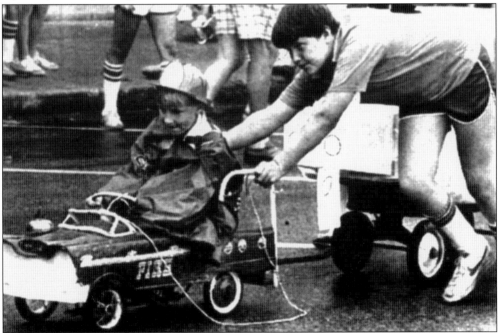

A helping hand is always appreciated, especially on a wet day. Rain or shine, unless there is a big storm, the parade goes on. Sometimes the younger participants need some help to get going. (Courtesy of Pioneer Press © 2008.)

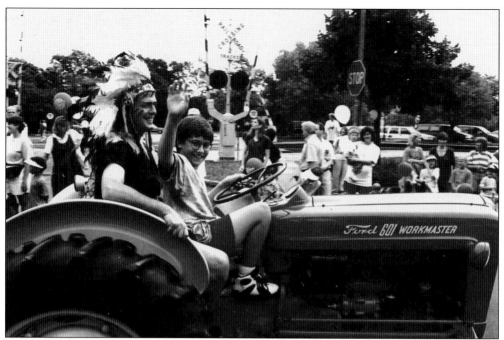

The Lake Forest Day parade attracts participants with many types of vehicles. In this entry, the passenger is dressed as a Native American chief and the young driver is showing off the antique tractor. While working farms and gentleman farms were common in 1908, this landscape has all but disappeared in the community. (Courtesy of Roger and Pauline Mohr.)

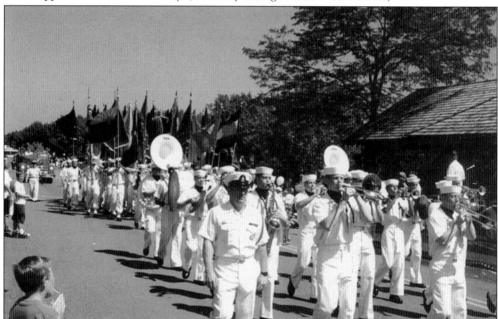

The U.S. Navy band from Great Lakes Naval Station marched in the 1996 parade. Started in 1911, the naval base was a major recruit training center for both World War I and World War II. Today Great Lakes Naval Station, located a few miles north of Lake Forest, is one of the U.S. Navy's most significant training centers. (Courtesy of Roger and Pauline Mohr.)

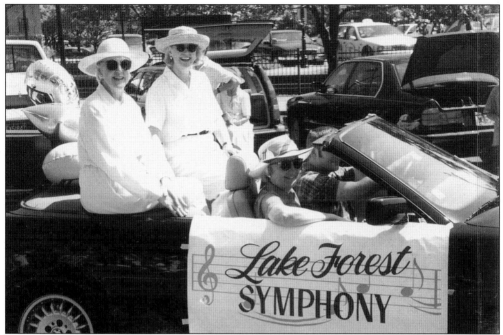

The Lake Forest Symphony, the only professional symphony in Lake County, has a regular schedule of concerts. It was started in 1957. The Lake Forest Symphony headquarters moved in 2002 to the Grove School Cultural Campus, which is on property that used to house a tuberculosis sanitarium. Pictured on the left in the photograph is Jean Beck, executive director. (Courtesy of Roger and Pauline Mohr.)

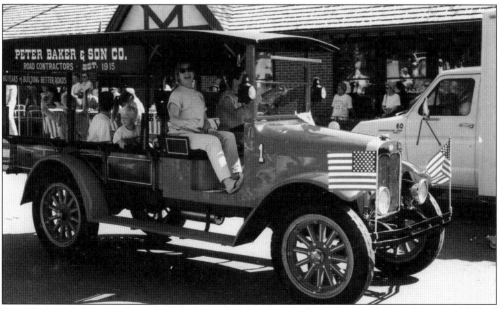

Peter Baker and Sons, shown in this parade photograph from the 1990s, is a long established business in Lake Forest. The road construction company started in 1915. A plant was established in 1938 where the current West Lake Forest train station stands. The company now operates in Rondout. (Courtesy of Roger and Pauline Mohr.)

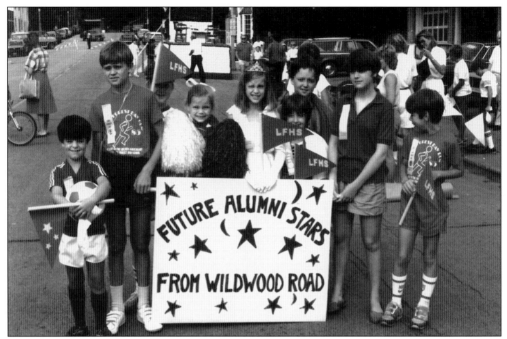

These young sports enthusiasts display their pride in their athletic abilities by marching as the "Future Alumni Stars from Wildwood Road" in the Lake Forest Day parade in 1985. From left to right, the stars are Kevin Garrity, Corey Turner, Courtney Turner, Tiffany Turner, Meghan Fitzgerald, Garrett Fitzgerald, Janelle Miller, and Ben Price. (Courtesy of Judy and Bud Turner.)

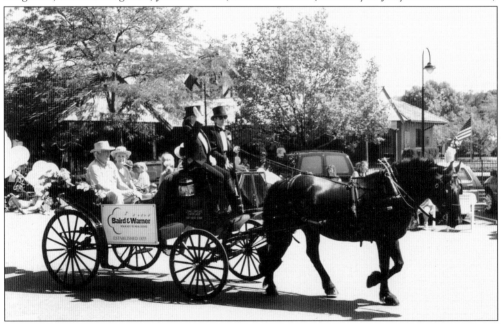

Baird and Warner, a local real estate firm, shows off their horse and carriage as they parade down the street. Lake Forest has one of the leading offices of Baird and Warner, Residential. The company is the largest independent estate broker in Illinois and the oldest in the country. The Lake Forest office opened in 1960. (Courtesy of Roger and Pauline Mohr.)

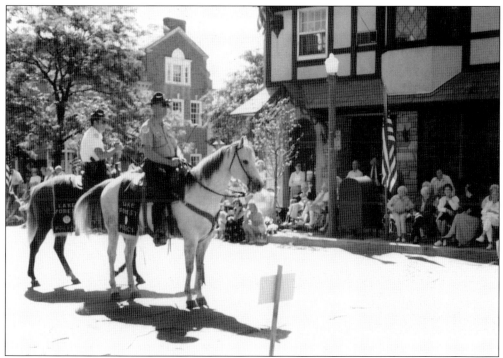

The mounted police of Lake Forest keep a watch over the crowd in this parade photograph. The Lake Forest Police Department provides school resource officers who act as liaisons between high school students and the police. The officers conduct programs and make appearances at local schools. (Courtesy of David O'Neill.)

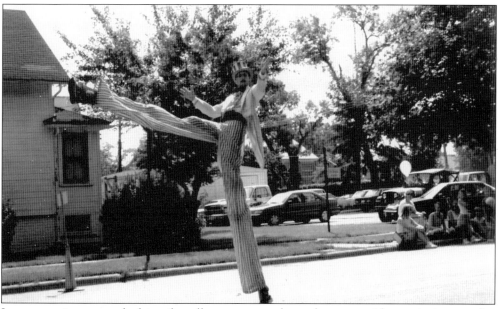

It was amazing to watch this stilt walker maneuver down the street without tripping over his own legs. He received a lot of laughter along the parade route. (Courtesy of Jeanne Goldman.)

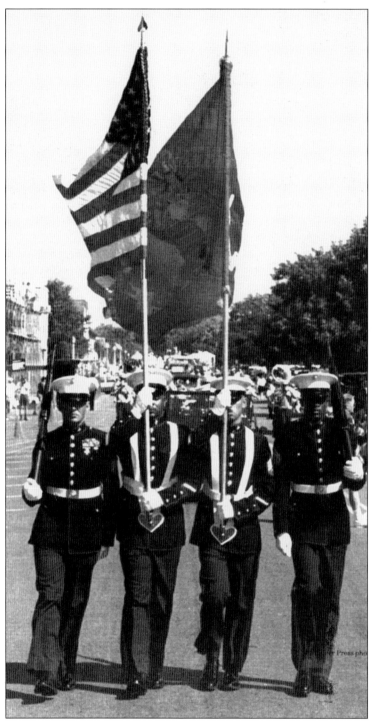

The Marine Corps Color Guard led the parade in 1997. Representatives from the U.S. Marine Corps, U.S. Navy, U.S. Army, American Legion, Boy Scouts, and Cub Scouts led the parades in different years. It is an impressive reminder of the role that patriotism and civic duty play in the festivities. (Courtesy of Pioneer Press © 2008.)

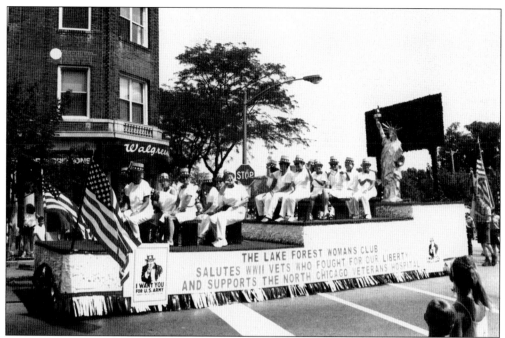

The Lake Forest Woman's Club saluted World War II veterans and the North Chicago Veteran's Hospital in 2001. The Lake Forest Woman's Club has been a big supporter of Lake Forest Day since they organized the first one in 1908. The club continued the tradition of large floats, even as the trend towards smaller entries prevailed. (Courtesy of Jean Grost.)

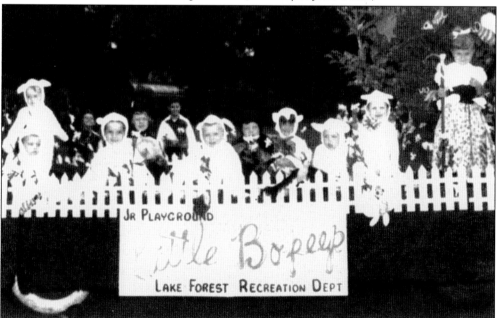

The Lake Forest Recreation Department entered this float called "Little Bo Peep." The children represented one of the recreation department's programs, the Junior Playground. The children are dressed as little lambs and are being watched over by Little Bo Peep. (Courtesy of Roger Petersen.)

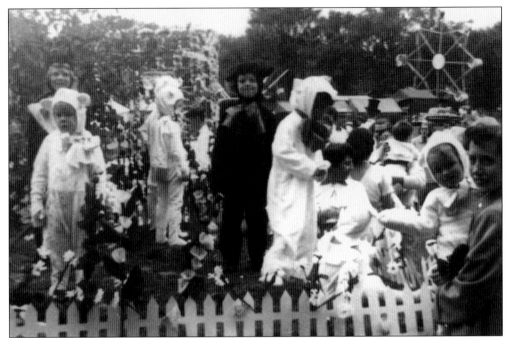

The Lake Forest Recreation Department oversaw this activity centered on Little Bo Peep. The recreation department was organized by the city and took over the building on Forest Avenue vacated by the Young Men's Club in 1948. They remained there until the new facility near Deerpath Park opened in 1978. (Courtesy of Roger Petersen.)

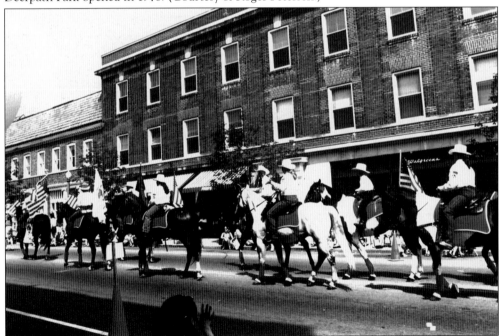

This horse troop was among the marching units to thrill the crowd in 2001. The Lake Forest-Lake Bluff Historical Society joined the show of horses in the early part of this century by showcasing polo ponies to advertise its annual polo match. (Courtesy of Jean Grost.)

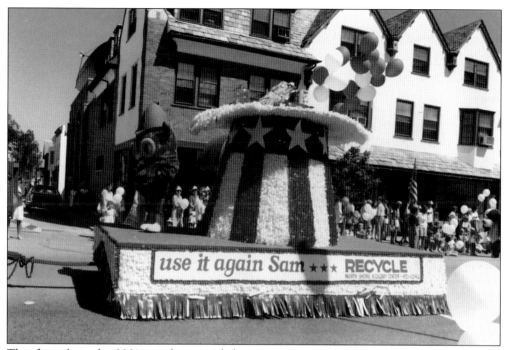

This float, from the 2001 parade, reminded everyone to recycle by reusing containers. Parade entries over the years reflected changes in culture—in this case, the beginnings of the green movement. In 2001, community organizations were saluted. (Courtesy of Jean Grost.)

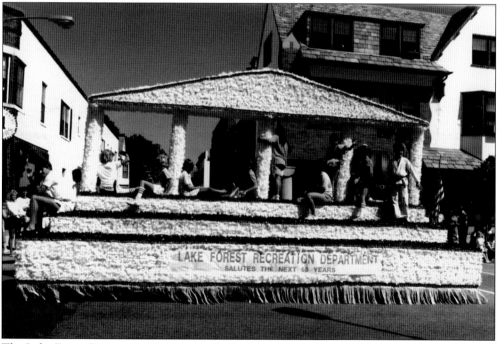

The Lake Forest Recreation Department looked forward to the next 50 years as they celebrated their 50th anniversary in 2001. The Recreation Center, located at 400 Hastings Road, serves all the citizens of Lake Forest with its variety of programs. (Courtesy of Jean Grost.)

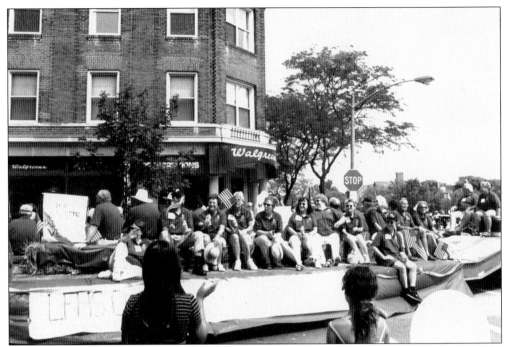

The Lake Forest High School class of 1951 celebrated its 50th anniversary in the 2001 parade. The Lake Forest High School has an active alumnae group that works hard to keep in touch with former students. (Courtesy of Jean Grost.)

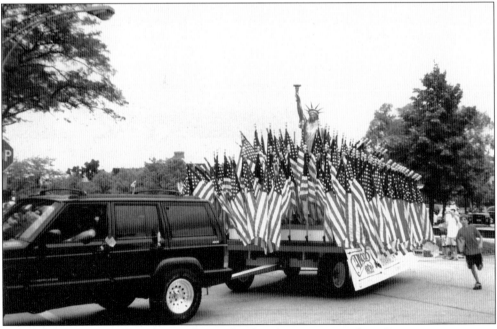

One of the features of the 2004 parade was this float boasting many flags. Promoting patriotism is one of the main missions of the American Legion and the idea found its way into many parade entries. In addition to flags, this float featured another patriotic symbol, the Statue of Liberty. (Courtesy of Jean Grost.)

Fire engines and police vehicles led many of the parades with their sirens blaring. This fire truck appeared in the 1981 parade. After occupying many locations within the business district, the fire and police department built a new facility on Deerpath, west of Deerpath Middle School. (Courtesy of Jean Grost.)

The O'Neill Hardware Store entered this horse and buggy in the parade for many years between 1948 and 1974. It was displayed because it was similar to the type of transportation used when the O'Neill Hardware Store opened in 1868. (Courtesy of David O'Neill.)

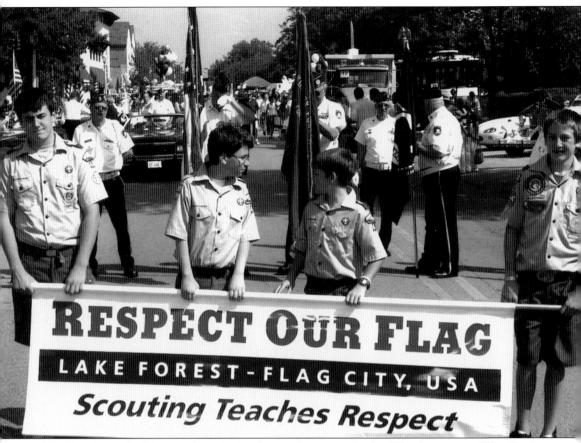

The Boy Scouts lead the parade with their banner honoring the flag. The designation "Flag City" is made by the group American Flag City. This organization supports men and women currently serving the United States, honors veterans of the U.S. Armed Forces, and teaches respect for the flag of the United States of America. Communities who participate are eligible for educational and advocacy materials in support of the flag. (Courtesy of Roger and Pauline Mohr.)

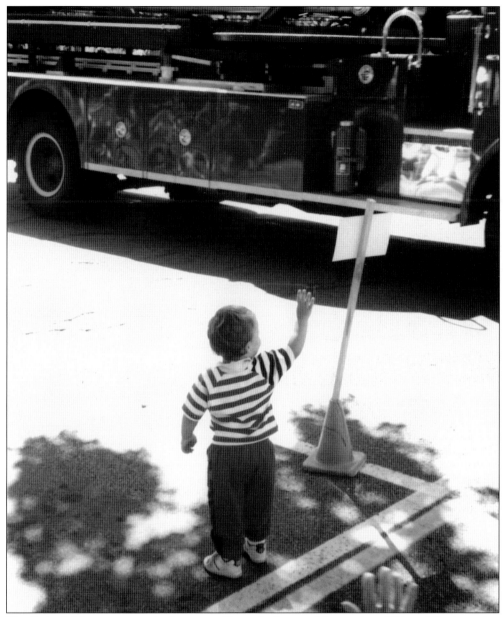

The little children are so excited to see and hear the large red fire engines. This toddler is waving to his friends, the firefighters. All up and down the parade route, hundreds of children do the same thing. (Courtesy of David O'Neill.)

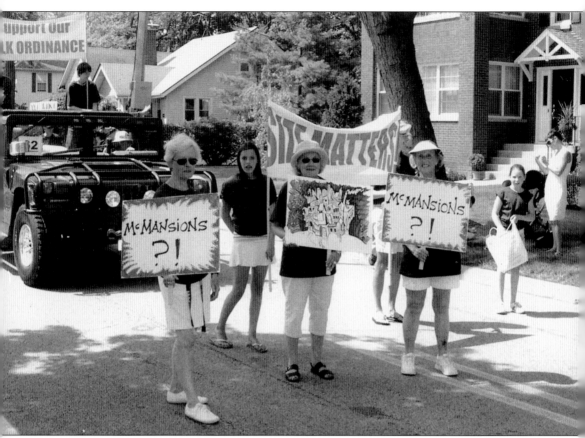

The Lake Forest Preservation Foundation was formed in 1976 to provide education about, advocate for, and fund historic preservation activities in the community. The organization is committed to preserving the historic visual character of Lake Forest. In this parade entry from the 1990s, members of the group warned against the building of "McMansions," homes constructed in a cookie-cutter fashion similar to the style of production of food at McDonald's restaurants. (Courtesy of Roger and Pauline Mohr.)

Seven

LAKE FOREST DAY THROUGH THE YEARS

The Lake Forest Woman's Club planned and held the first Lake Forest Day in 1908. The next year, the Young Men's Club requested permission to hold the event to raise money for their new club house. The Young Men's Club and the Commercial Association ran Lake Forest Day through 1920. In 1921, the newly established American Legion McKinlock Post 264 took over the running of the event. The American Legion still organizes and runs the celebration each year.

In the early years, firecrackers were set off on Market Square to announce the start of the parade. Parades were introduced in the early part of the second decade of the 20th century with children participating during many of the years. Parades were not held in the 1930s, but returned again in 1940.

Starting in 1938, the Lake Forest American Legion Post 264 chose a theme for Lake Forest Day. The theme "Fun for All" was used for five years. With the advent of World War II the themes became more patriotic, such as "Home Defense," "Prelude to Victory," and "On to Tokyo."

This annual celebration has changed over the years to reflect local interests, national events, and even cultural shifts. Some of the features included greased pig contests, silent movies, stunt flyers, boxing matches, motorcycle races, band concerts, and vaudeville programs. Dancing was held at West Park on a wooden platform that was erected for the dancers. In the early 1920s, Charles J. Correll and Freeman F. Gosden (later to become Amos and Andy of radio and television fame) helped put on the vaudeville shows.

Starting in 1925, there was a grand prize drawing. For several years, an automobile, a refrigerator, a bicycle, as well as smaller appliances and gifts were given away around midnight. In later years, a grand prize of $5,000 in cash was awarded.

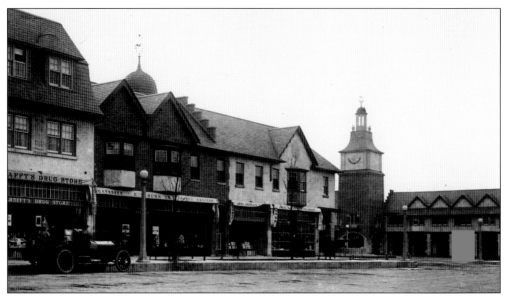

Market Square has been the center of the community since it opened in 1917 and has been an integral place for the parade activities since that time. Market Square, designed by renowned architect and local resident Howard Van Doren Shaw, is the first planned shopping center in the United States. It was developed by a group of local citizens in one of the many public-private partnerships to enhance the city. (Courtesy of Lake Forest-Lake Bluff Historical Society.)

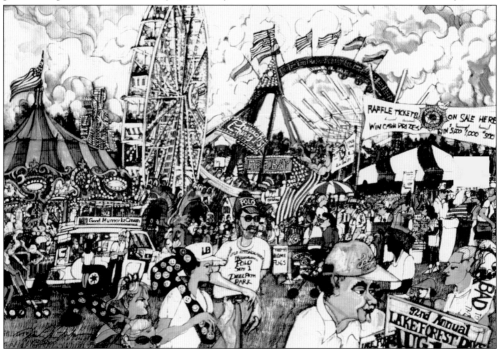

Renowned local artist Franklin McMahon did this drawing of the Lake Forest Day carnival in West Park. It was later turned into a poster. McMahon's distinctive style is both colorful and documentary, catching a full range of images in one piece of art. (Courtesy of the McMahon family.)

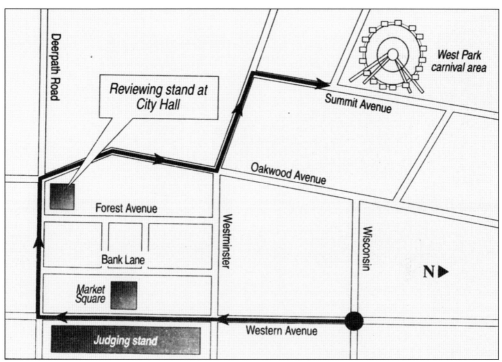

Each year, the *Lake Forester* printed the parade route for the day. Recent parades have started on Western Avenue, moved past Market Square, and continued along Deerpath, Oakwood Avenue, Westminster Road, and Summit Avenue to end in West Park. The carnival and fair were set up for the rest of the day in West Park. (Courtesy of Pioneer Press © 2008.)

In 1910, an advertisement appeared in the local newspaper, *Lake Forester*, advertising Lake Forest Day. Motorcycle racing was a popular draw as vehicles were still a relatively new invention. The first commercial Harley-Davidson was built in 1903. Local men participated in the baseball games and the bicycle and foot races. Ladies on the other hand were restricted to dancing as an acceptable physical activity. (Courtesy of Pioneer Press © 2008.)

LAKE FOREST DAY

Celebration at Farwell Field

Wednesday, August 10th

MOTOR CYCLE ROAD RACE
BASE BALL BICYCLE and FOOT RACES
Amusements and Sports of all kinds

Exhibition Drill by Woodmen Drill Team

DANCING
AFTERNOON EVENING

Dinner and Refreshments Served on Grounds

COME EARLY SPORTS BEGIN AT 10 O'CLOCK

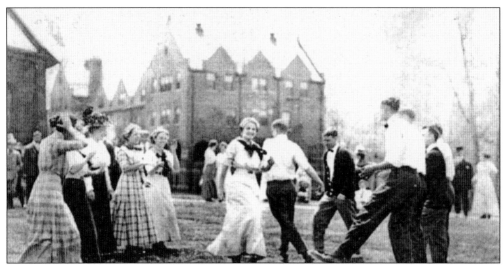

Dancing styles underwent a major upheaval in the early 20th century. These Lake Forest College students appear to be taking a break from their studies in 1911 to engage in traditional square dancing. Square dancing at this time consisted of a limited number of basic movements, or "calls," enabling the average dancer to join the group by assimilation rather than by taking a series of lessons. (Courtesy of Lake Forest College.)

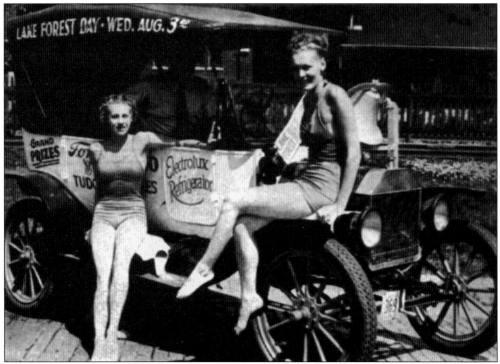

Two bathing beauties are shown advertising the upcoming 1934 Lake Forest Day. They rode around town inviting the citizens to enjoy the festivities for the week. (Courtesy of Lake Forest-Lake Bluff Historical Society.)

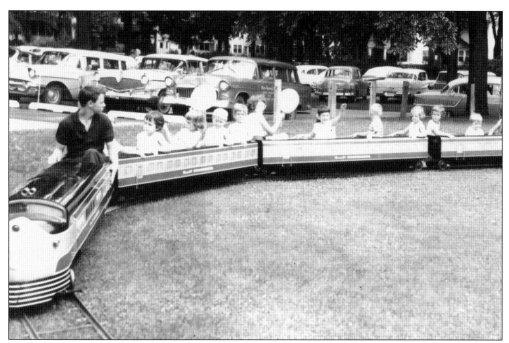

One of the exciting features for the young children in 1943 was this train ride around West Park. The toddlers who were too young for the big rides found this one was just perfect for them. (Photograph by Ward H. McMasters; courtesy of Jean Grost.)

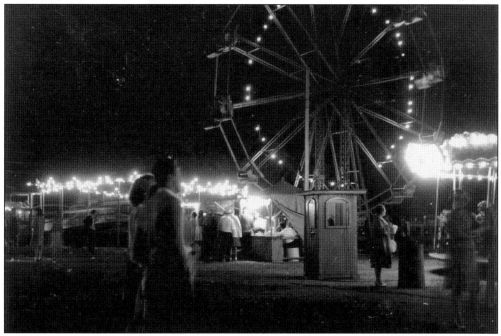

Lake Forest Day celebrations in West Park went on until late at night, and the grounds were lit up to draw patrons. In the evening, along with the carnival, a dance was often held. In 1943, the grand prizes were awarded at midnight after the dancing. (Photograph by Ward H. McMasters; courtesy of Jean Grost.)

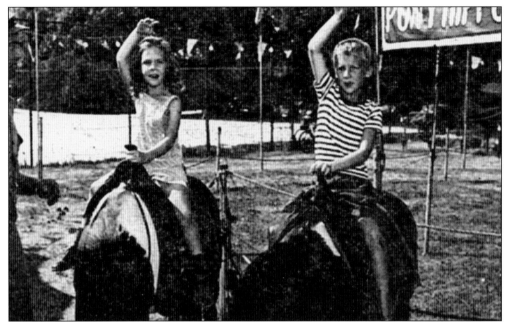

A popular feature at the fair ground was the Pony Hippodrome where children could ride horses and pretend to be cowboys and cowgirls. Taking their turns on the ponies in 1946 are Lynn Todd (left) and Murray Washburn. (Courtesy of Pioneer Press © 2008.)

Lake Forest Day Specials

Group of Children's Dresses and Boys' Suits—
Sizes 1 to 12, up to $3.00—NOW 2 for $3.00

Group of Children's Play Suits, Blouses, Boys' Suits—
Sizes 2 to 6 years, up to $3.00—NOW 2 for $1.50

All Sales final. Cash Only. No refunds or exchanges. Store will be open every evening this week until 8 p. m. Other great reductions on everything.

The days surrounding Lake Forest Day were a popular time for local merchants to advertise special sales at their stores. For many years, local shops were closed on Wednesday afternoons year-round. Thus the tradition of having Lake Forest Day on a Wednesday developed so the local merchants could participate in the festivities on the day they were partially closed. (Courtesy of Pioneer Press © 2008)

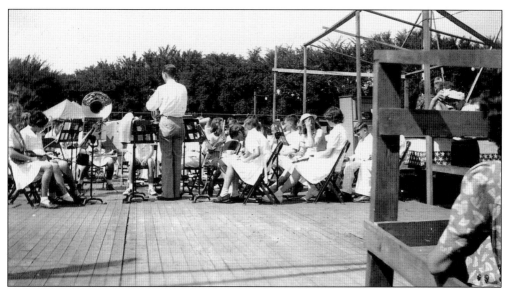

For many years, a platform was erected in West Park. It was used for performances by the local school bands and other talents that were showcased during Lake Forest Day. At the end of the day the wooden platform was cleared and used for dancing. (Courtesy of Lake Forest-Lake Bluff Historical Society.)

Wilson Dennehy (left) and Jack Parks are shown enjoying the treat of pink cotton candy in 1946. (Courtesy of Pioneer Press © 2008.)

From left to right, Tommy Campbell, Bobbie Lundeen, Bobby Kiddle, and Lorraine Franzen won ribbons for being the winners of the foot races. This picture was taken during the 1946 Lake Forest Day celebration. (Courtesy of Pioneer Press © 2008.)

High on the ferris wheel are, from left to right, Harriet Arpee, Stephen Arpee, and Mary Allen having fun at the carnival in 1946. The carnival was always a popular place for young people during Lake Forest Day. (Courtesy of Pioneer Press © 2008.)

Johnnie (left) and Tommie Gross enjoyed their cotton candy on a hot summer day. They were ready to spend the day riding rides, playing games, racing against the other children, and watching the men play baseball. (Courtesy Pioneer Press © 2008.)

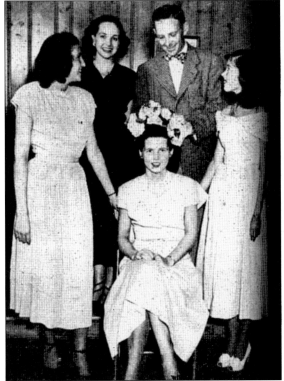

O. B. Petersen, head of the American Legion queen contest, crowned Rose Ann Kerr as 1948's Miss Lake Forest Day. Looking on were (from left to right) Celeste Rogodino, Marion O'Keith, and Mary Hesterman. Miss Lake Forest Day was chosen for her facial beauty, poise, and personality. (Courtesy of Pioneer Press © 2008.)

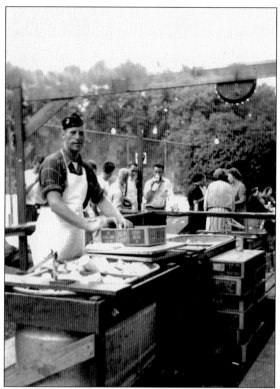

The American Legion ran food stands on the carnival grounds as a way to raise funds to cover the cost of the day. Hamburgers, hot dogs, popcorn, and cotton candy were sold. Members of the American Legion, represented by Bob Oliver, as well as other local citizens, did the cooking. These food stands were very popular with the crowd. (Courtesy of Audrey Semmelman.)

From left to right, Charlie Scher, Andy Semmelman, Kay Kerrigan Weston, Ed Burns, and Audrey Henriksen Semmelman had fun at the Beer Garden at West Park in the early 1950s. The Beer Garden was a popular place to quench one's thirst after a long day at the carnival. (Courtesy of Kay Kerrigan Weston.)

Kay Kerrigan Weston and John "Froggy" Fredrikson took the opportunity to rest behind the Beer Garden during Lake Forest Day in the early 1950s. The empty beer cases piled high made a good backrest as the two cooled off. The Beer Garden and the food booths were very popular attractions. (Courtesy of Kay Kerrigan Weston.)

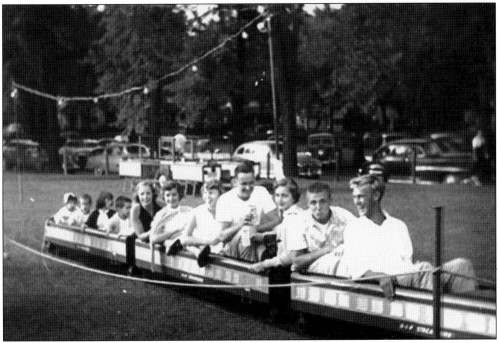

A group of friends enjoyed riding the train around West Park in 1953. The day offered many opportunities for groups of young men and women to have a day of fun. (Courtesy of Kay Kerrigan Weston.)

In 1997, Herb Faulks was proclaimed "Mr. Lake Forest Day." His inspiring service legacy includes volunteering for the Boy Scouts (through his membership in American Legion McKinlock Post 264) and service as a Lake Forest councilman, city treasurer, city marshall, and city collector. For over 30 years, Faulks has volunteered for Lake Forest Day both by wiring West Park for electricity for the carnival and by serving as parade marshal.

Dr. Theodore S. Proxmire holds one of the latest babies he delivered just before Lake Forest Day 1955. Twelve-day-old Kathie Lee Kilgore is shown with her mother, Mrs. Leroy Kilgore, and James Peddle, the oldest baby Dr. Proxmire delivered. This scene was repeated many times during the celebration by grateful families. Dr. Proxmire was a beloved and respected doctor in Lake Forest. (Courtesy of Lake Forest-Lake Bluff Historical Society.)

Races were held for all age groups. In this event from 1968, girls put all their effort into the race hoping to win the blue ribbon. (Courtesy of Pioneer Press © 2008.)

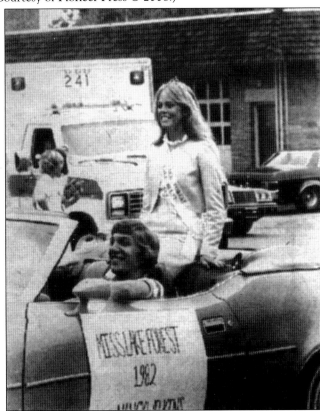

Nancy Wilkins became Miss Lake Forest in 1982. In 1927, the American Legion advertised a beauty contest, but no one was brave enough to sign up, and the contest was canceled. Miss Lake Forest contests were held in different years starting in the 1940s. (Courtesy of Pioneer Press, © 2008.)

Despite the rain the children enjoy the parade in 1995. Rain or shine, the parade and the carnival went on. The crowds always came despite the weather. 1960 was a memorable year, when violent storms hit the area just as the children's parade was ready to begin. (Courtesy of Pioneer Press © 2008.)

Dana Thompson (left) and Emily Macmillan watch the parade from a comfortable seat in their wagon in 1995. Parade watchers brought chairs and wagons to the parade route so that they could watch in comfort. Some lucky citizens could watch from their own front yard. (Courtesy of Pioneer Press © 2008.)

Brandon Kinas from Great Lakes Naval Training Station tries out one of the many games at the carnival. Admirers watch as he pits his strength to try to ring the bell. Great Lakes Naval Training Station is only a few miles north of Lake Forest. (Courtesy of Pioneer Press © 2008.)

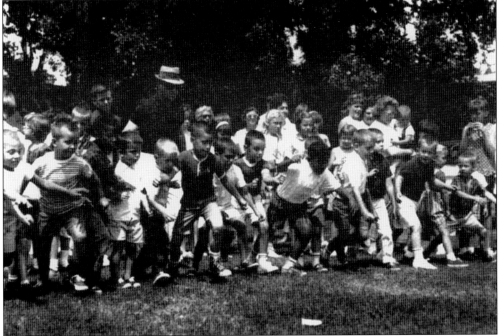

Get ready, get set, go. The little children are ready to run their fastest to win the blue ribbon. Children loved to join in the races even if they did not win; it was just fun to run with all the other children. (Courtesy of Pioneer Press © 2008.)

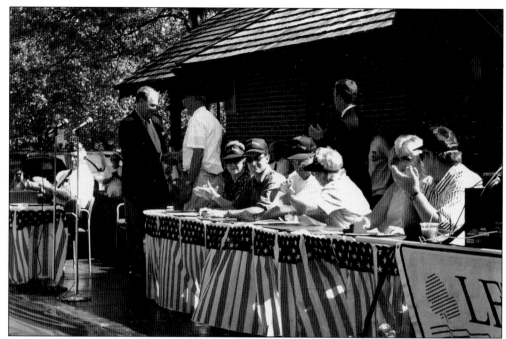

Prominent citizens and visitors judged the parade entries every year. There were several categories such as commercial, beauty, humor, and others. Trophies were awarded to the winners. In recent years, the parade has been videotaped and shown on the local community cable station. (Courtesy of Roger and Pauline Mohr.)

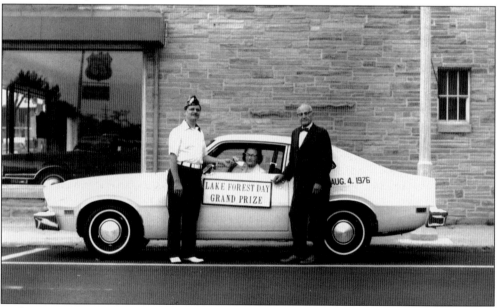

Each year, a grand prize from a raffle was awarded at midnight. The main prize for many years was a new automobile donated by one of the local dealerships. Also awarded were bicycles, refrigerators, freezers, electric ironers, mixers, and other small appliances. In later years, the grand prize was $5,000. Pictured are Larry Crone (left) and Floyd Swarthout of C&S Motors, located on Western Avenue. (Courtesy of Lake Forest-Lake Bluff Historical Society.)

Eight

LAKE FOREST DAY, THE PRESENT

Lake Forest will mark the 100th anniversary of Lake Forest Day on August 6, 2008. Lake Forest Day continues to have broad community support and participation. Residents, organizations, and businesses have joined the American Legion McKinlock Post 264 to plan the centennial celebration. The centennial committee has been promoting the idea for local residents to make Lake Forest their vacation spot in August 2008.

Many interesting and fun activities are planned for young and old alike. The celebration will stretch over several days and locations. On Saturday, August 2, 2008, a "Family Beach Ball" event will take place at Lake Forest beach with musical entertainment and other fun activities. The following Tuesday and Wednesday, the traditional carnival will provide games and rides for children. The celebration will culminate in an expanded parade on Wednesday, August 6, 2008, featuring neighborhood floats and several marching bands. Astronaut Capt. James A. Lovell (U.S. Navy, retired) will be the grand marshal. Presiding over the festivities will be Lake Forest mayor Michael Rummel.

The Lake Forest Day Centennial Committee is chaired by former mayor John E. Preschlack. The American Legion's leadership includes Floyd "Bud" Turner, Lake Forest Day chairman, and David Lee, commander. As part of the centennial committee's legacy, an endowment has been established to ensure that this important community tradition continues.

The Lake Forest Day committee commissioned this design of a logo for the 100th anniversary of the event. The logo will be used on vehicle stickers, brochures and other marketing pieces about the 2008 Lake Forest Day activities. The logo is also displayed on the special Web site set up for the celebration and will raise community awareness of this important anniversary. (Courtesy of the City of Lake Forest.)

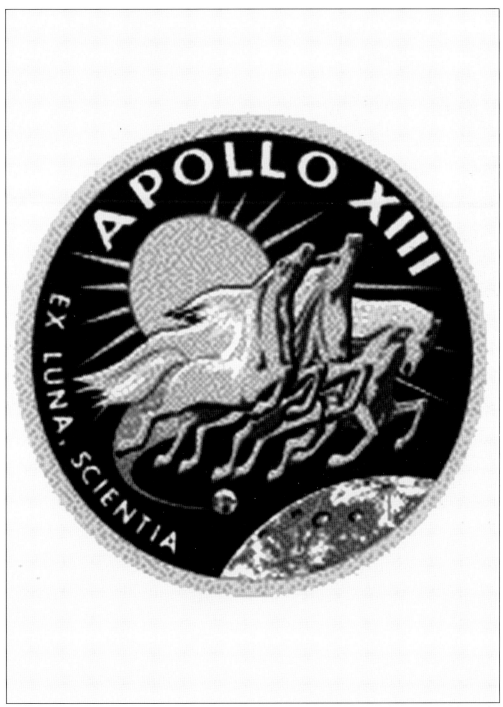

Local resident astronaut James Lovell is set to serve as grand marshal for the centennial parade. He commanded Apollo 13, which launched on April 11, 1970. During the flight, an explosion disabled the ship. During several harrowing days, family, friends, and people around the world anxiously followed news reports, keeping track of the fate of Apollo 13. The ship safely splashed down on April 17 much to everyone's relief. (Courtesy of NASA.)

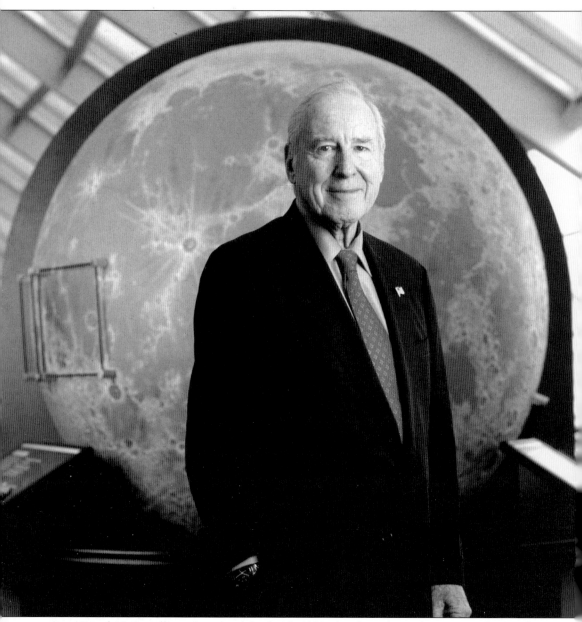

Capt. James A. Lovell was born on March 25, 1928. A talented naval aviator and test pilot, he was chosen for the space program in 1962. After serving in the Gemini program, Captain Lovell made three voyages to the moon, on Apollo 8, Apollo 11 (during which he landed on the moon), and Apollo 13. He served as spacecraft commander of Apollo 13 in 1970 and along with his crewmates, acted to preserve lives and make it safely home when the cryogenic oxygen system failed. A student of the University of Wisconsin and a graduate of the Harvard Business School's Advance Management Program, Captain Lovell easily made the transition from astronaut to businessman. In 1999, he and his family, including his son, talented chef Jay Lovell, opened Lovells of Lake Forest, an elegant full-service restaurant. A respected and revered local resident, Captain Lovell is set to serve as the grand marshal of the Lake Forest Day Centennial Parade in 2008. (Courtesy of Capt. James A. Lovell.)

Floyd "Bud" Turner looks on at the Rifle Squad rendering honors to 2nd Lieutenant Matt Coutu, a local man who was killed in the Iraq War. The Legionnaires bring solemnity and dignity to all of their memorial observations. Turner is the American Legion Lake Forest Day chair for 2008. (Courtesy of Judy and Bud Turner.)

Laboring diligently behind the scenes, the Legionnaires carry on the tradition of Lake Forest Day. Turner, the 2008 American Legion Lake Forest Day chair, sits with service officer Larry Crone on his right and Com. David Lee on his left. Thanks to their efforts, the community continues to enjoy its annual summer festival. (Courtesy of Judy and Bud Turner.)

Michael Rummel became mayor of the city of Lake Forest on May 9, 2005, and is mayor during the centennial year. He previously served as second ward alderman for four years. Rummel is president of Rummel Associates, an insurance brokerage firm in Chicago. Rummel and his wife, Melanie, have lived in Lake Forest with their children, Jared and Jessica, for over 18 years. (Courtesy of City of Lake Forest.)

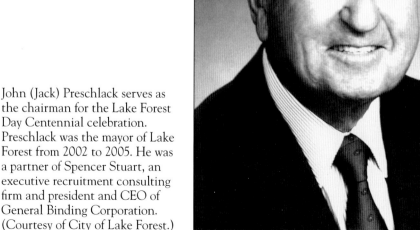

John (Jack) Preschlack serves as the chairman for the Lake Forest Day Centennial celebration. Preschlack was the mayor of Lake Forest from 2002 to 2005. He was a partner of Spencer Stuart, an executive recruitment consulting firm and president and CEO of General Binding Corporation. (Courtesy of City of Lake Forest.)

INDEX

ACROSS AMERICA, PEOPLE ARE DISCOVERING SOMETHING WONDERFUL. *THEIR HERITAGE.*

Arcadia Publishing is the leading local history publisher in the United States. With more than 3,000 titles in print and hundreds of new titles released every year, Arcadia has extensive specialized experience chronicling the history of communities and celebrating America's hidden stories, bringing to life the people, places, and events from the past. To discover the history of other communities across the nation, please visit:

www.arcadiapublishing.com

Customized search tools allow you to find regional history books about the town where you grew up, the cities where your friends and family live, the town where your parents met, or even that retirement spot you've been dreaming about.